To

From

Date

ALL CREATURES OF OUR GOD AND KING

Coloring Book

All Creatures of Our God and King Coloring Book

Copyright © 2016 by Zondervan

Requests for information should be addressed to:

Zondervan, 3900 Sparks Dr., SE, Grand Rapids, MI 49546

ISBN 978-0-310-34878-8

Cover design: Patti Evans
Cover photography or illustration: Suzanne Khushi and Julianne St. Clair
Interior illustration: Suzanne Khushi and Julianne St. Clair
Interior design: Patti Evans

Printed in the United States
16 17 18 19 20 /RRD/ 22 21 20 19 18 17 16 15 14 13 12 11 10 9 8 7 6 5 4 3 2 1

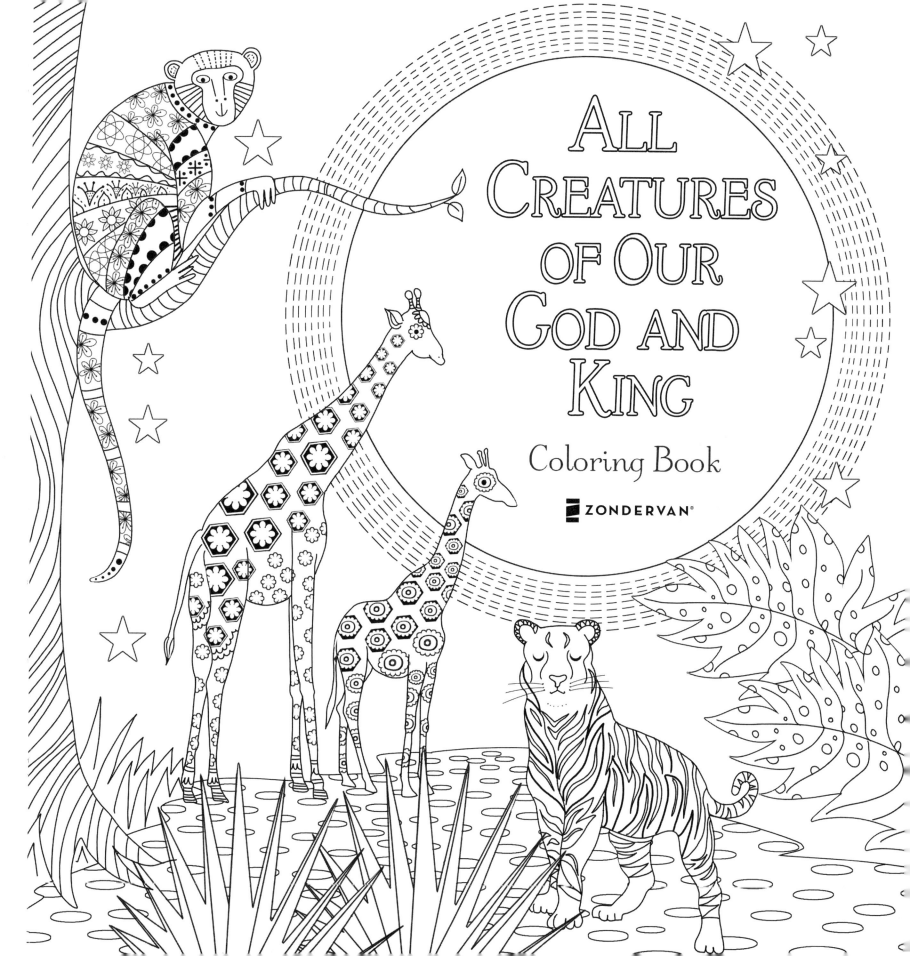

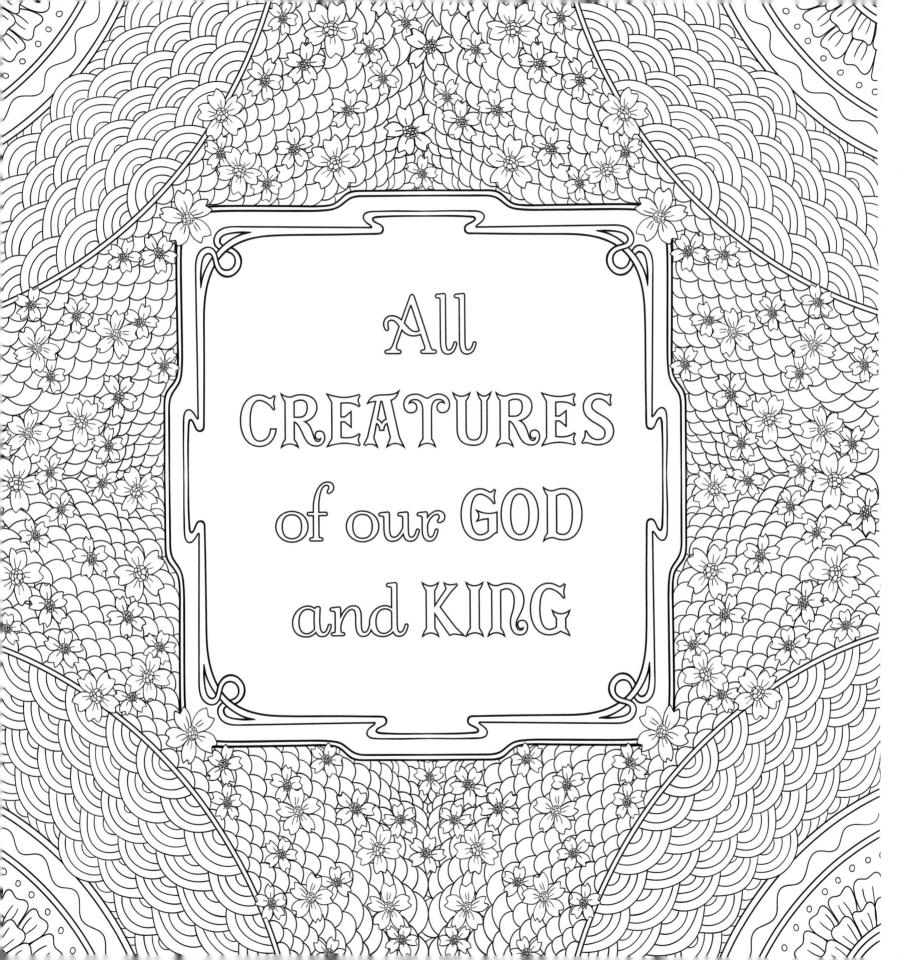

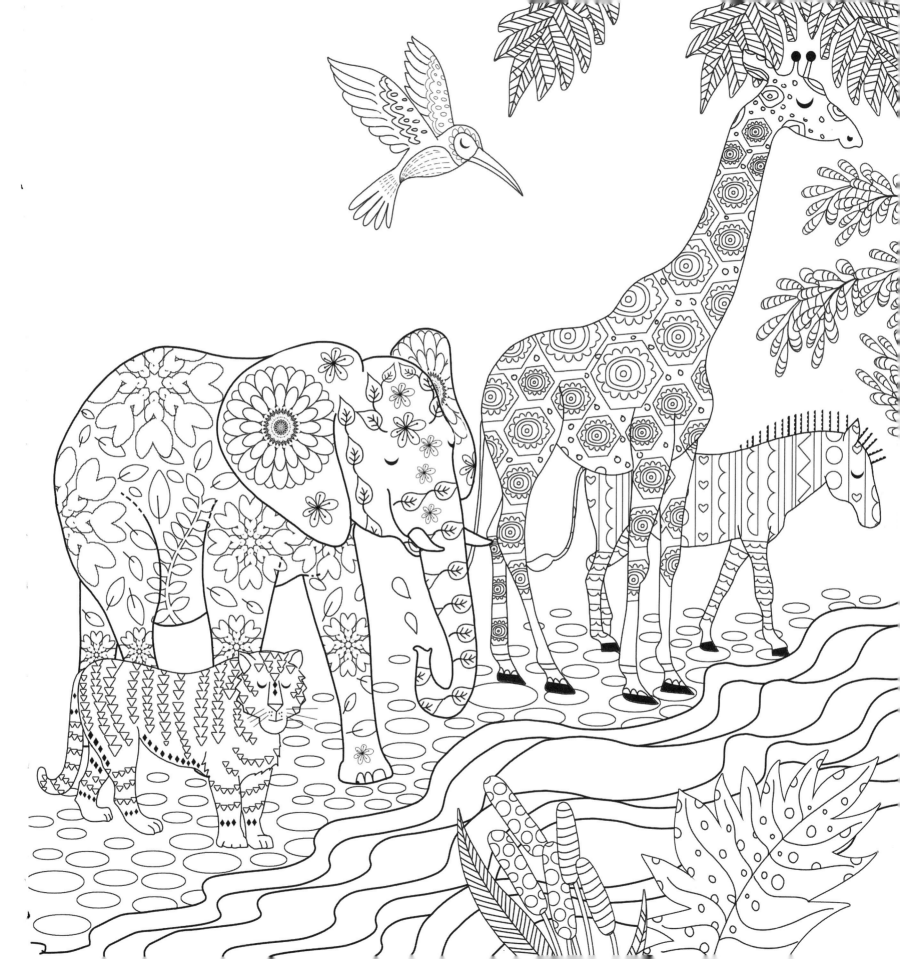

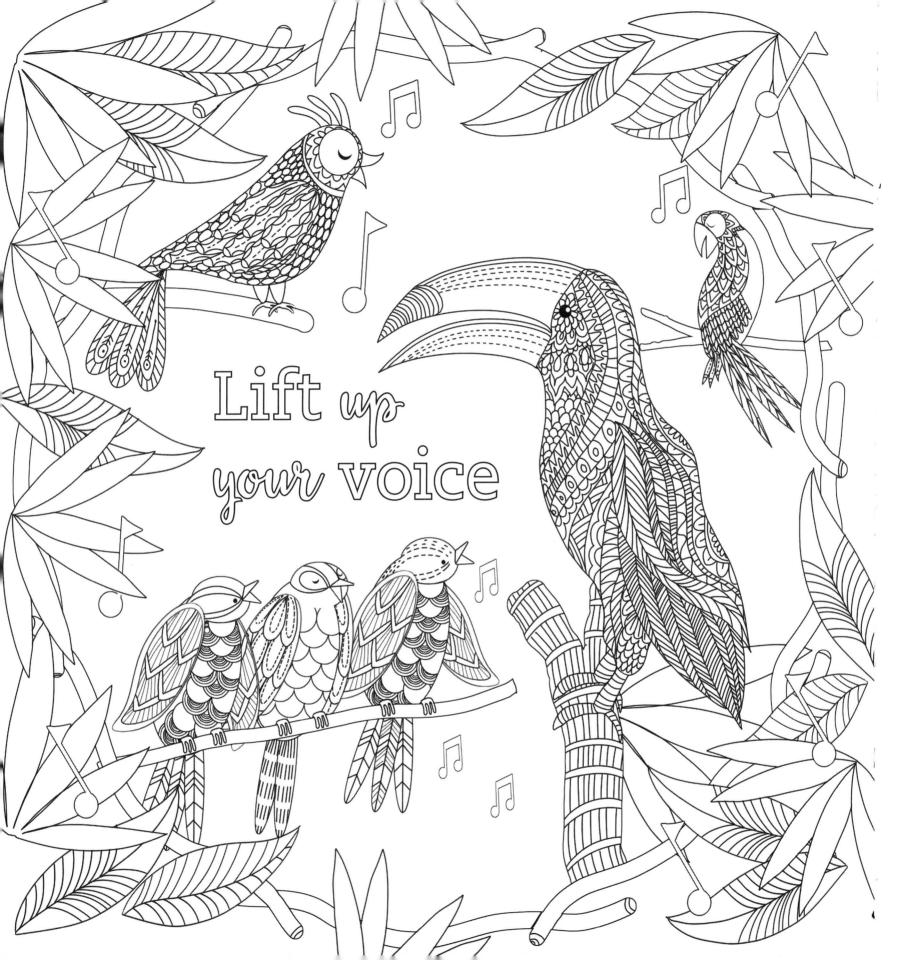

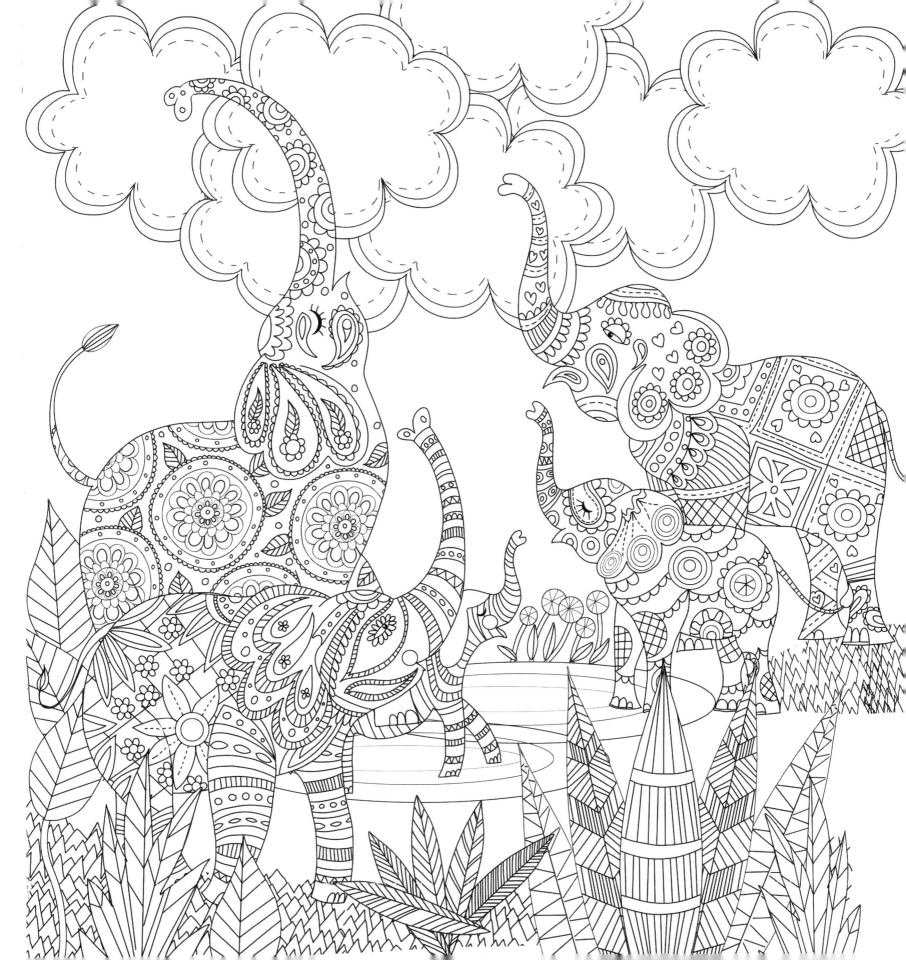

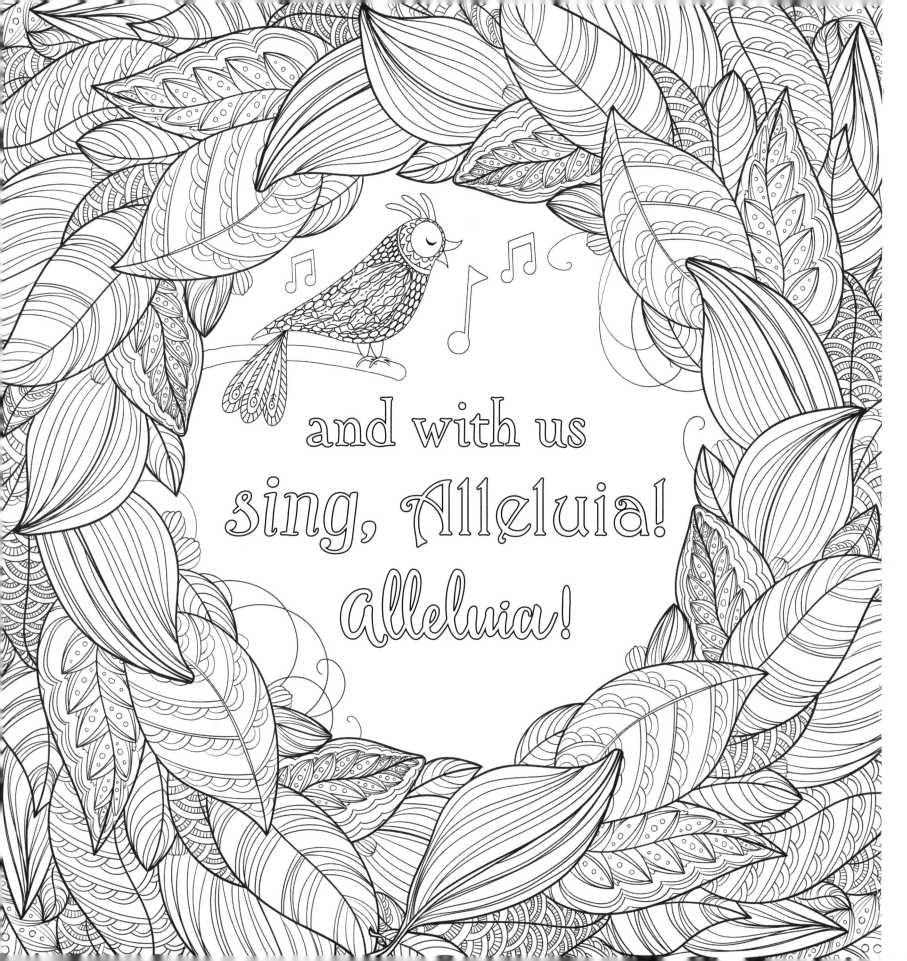

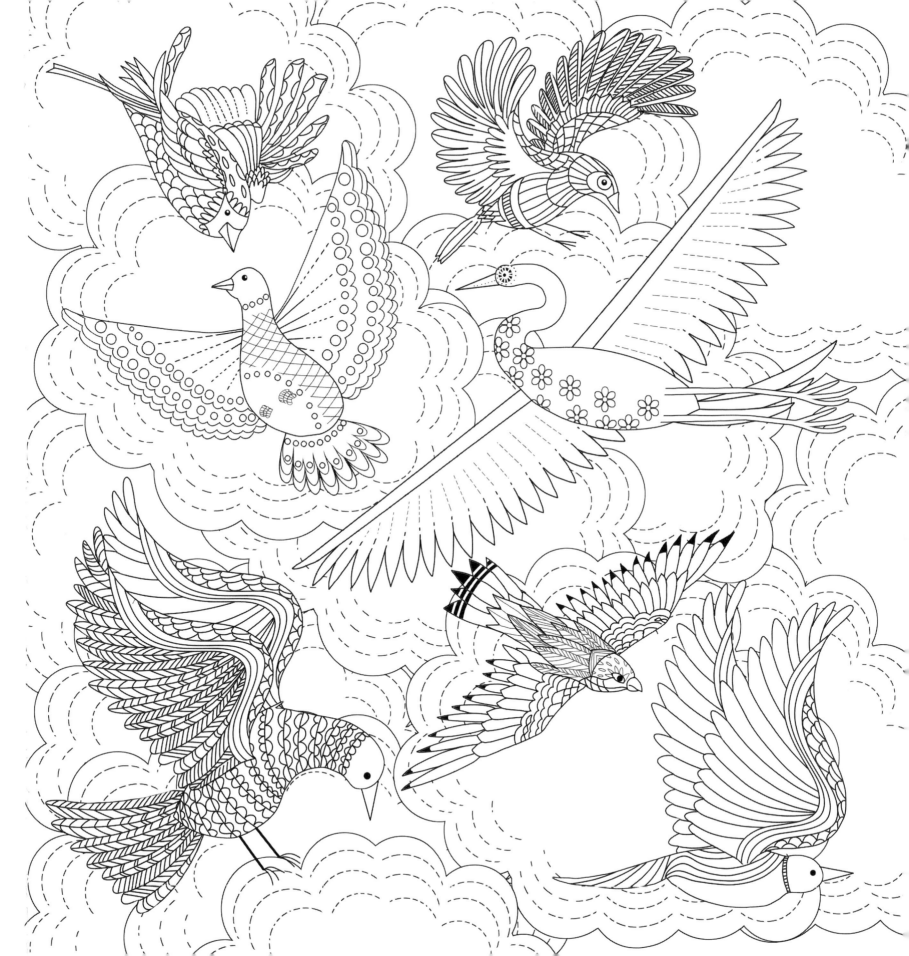

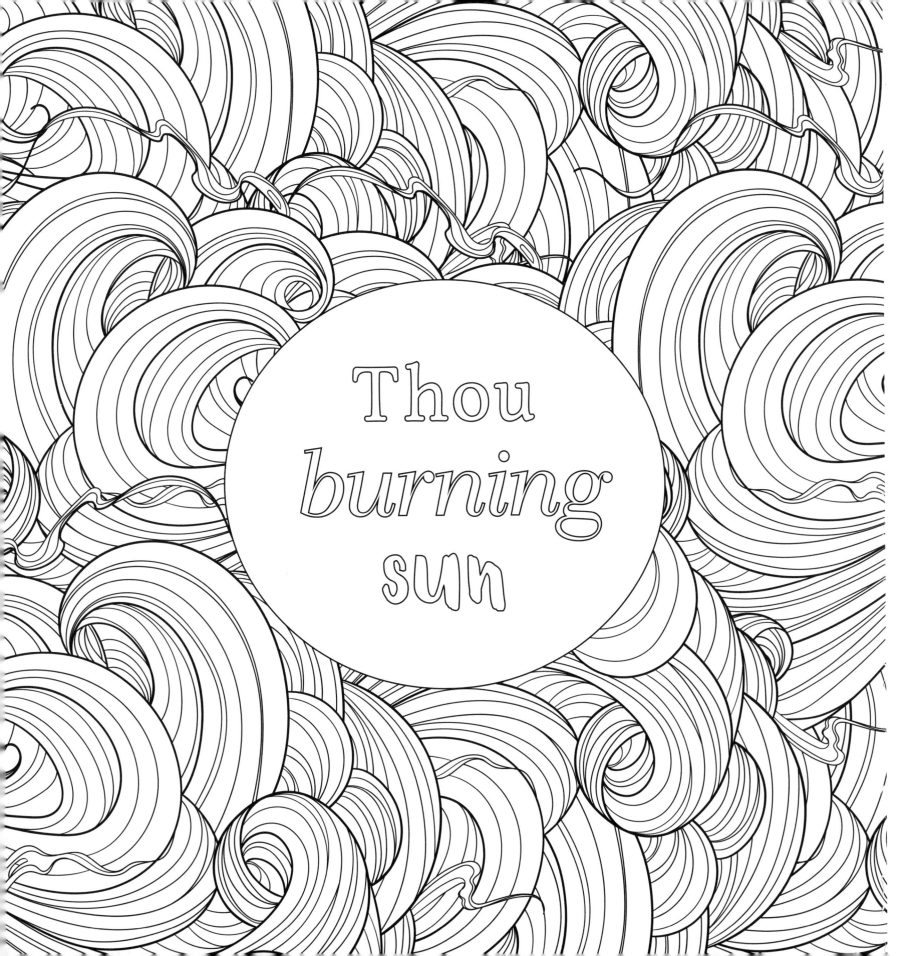

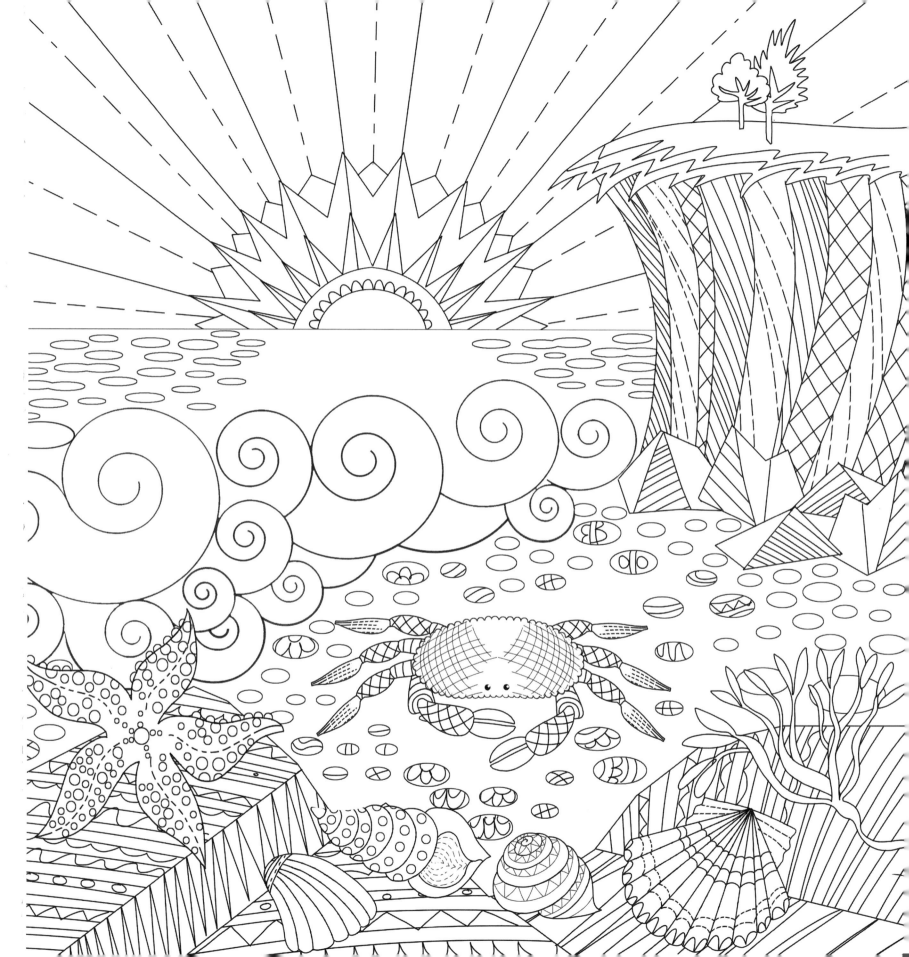

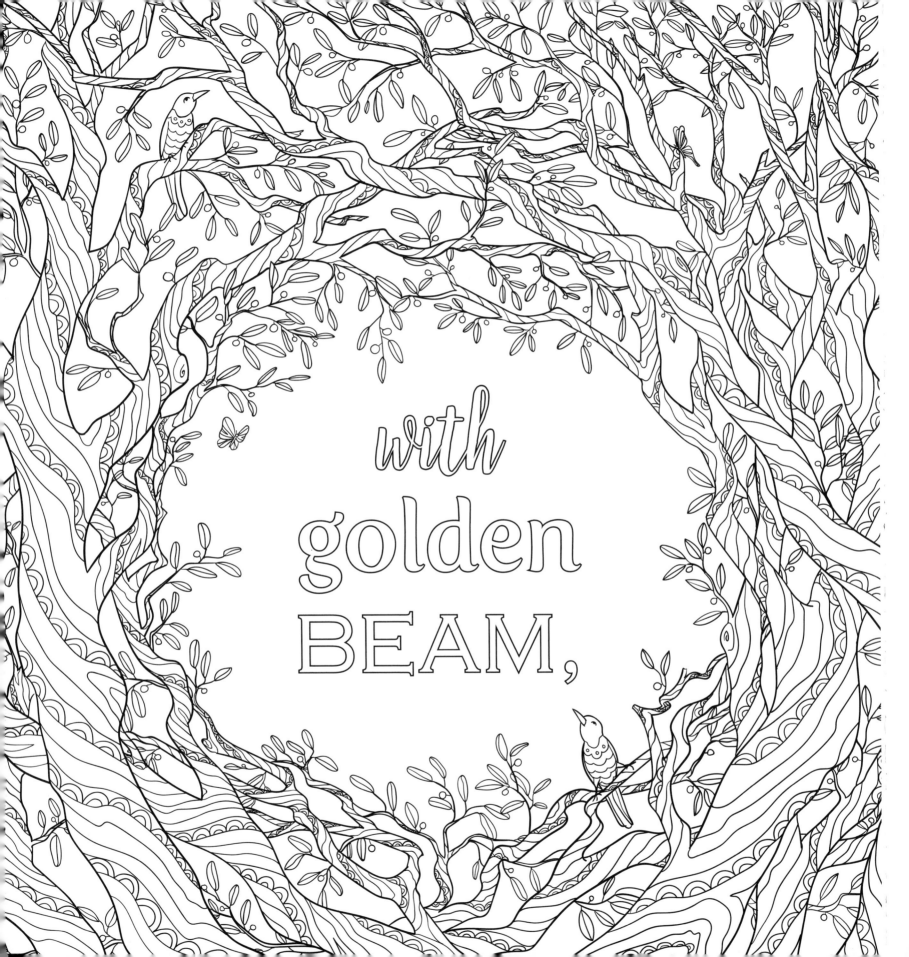

with
golden
BEAM,

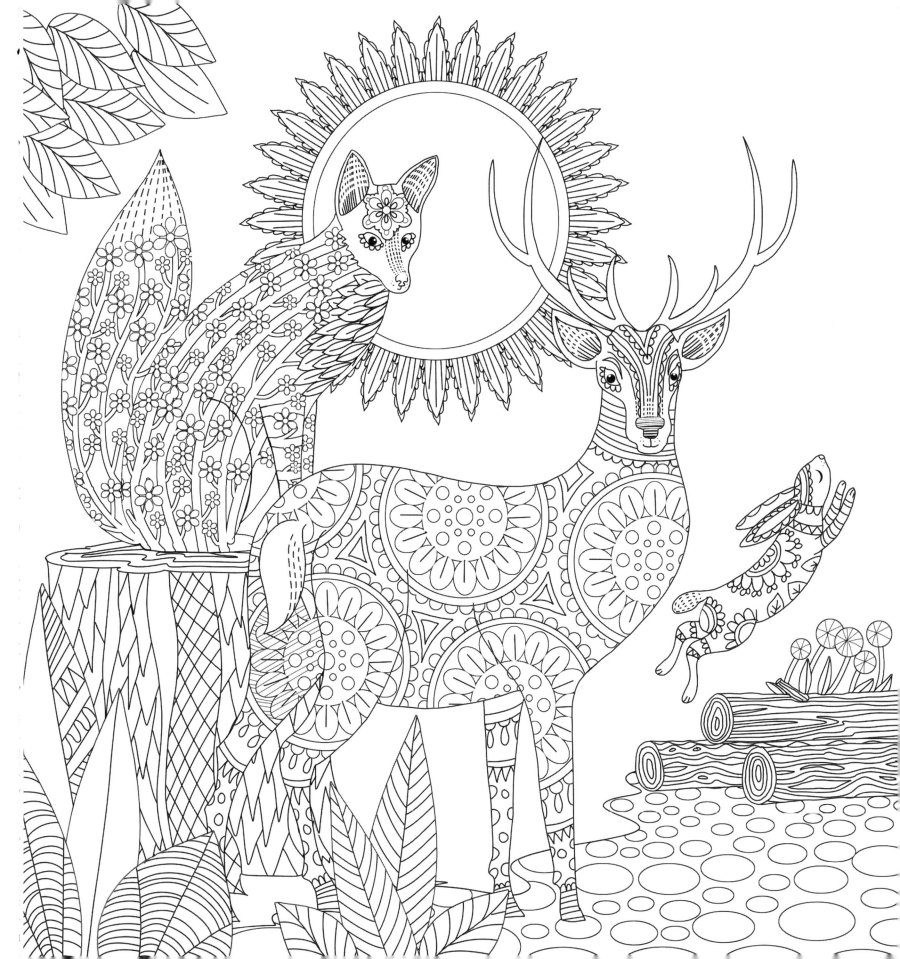

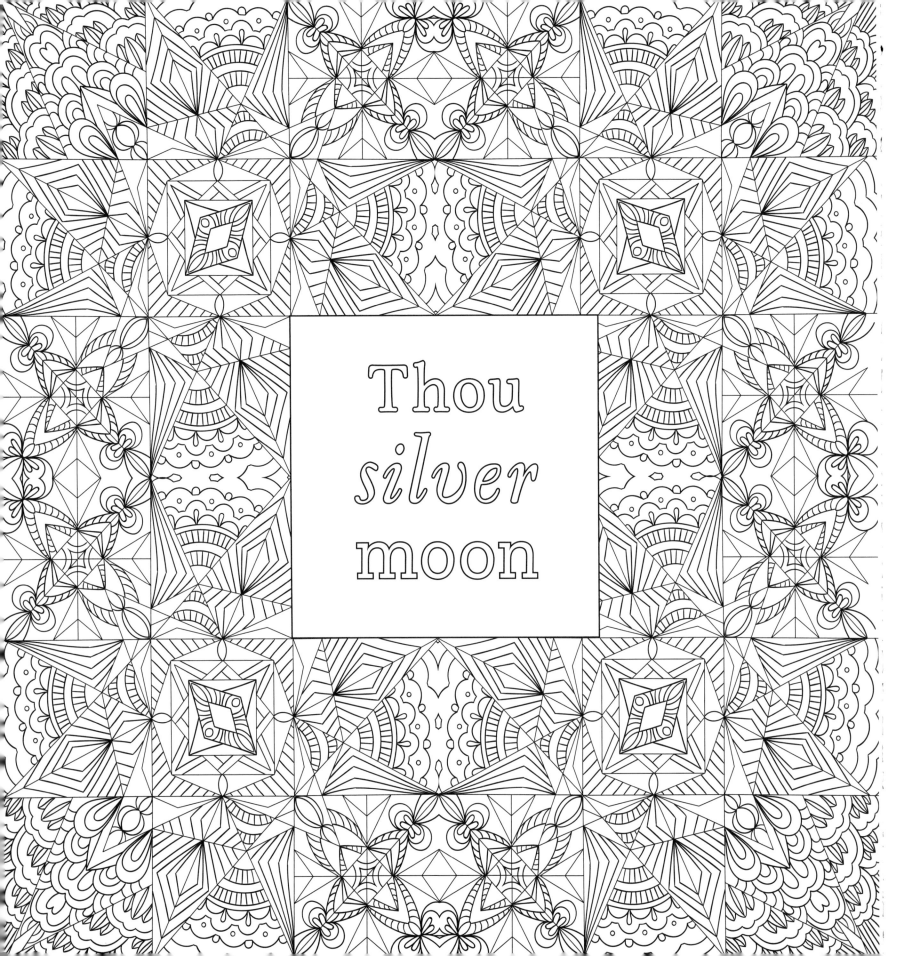

Thou *silver* moon

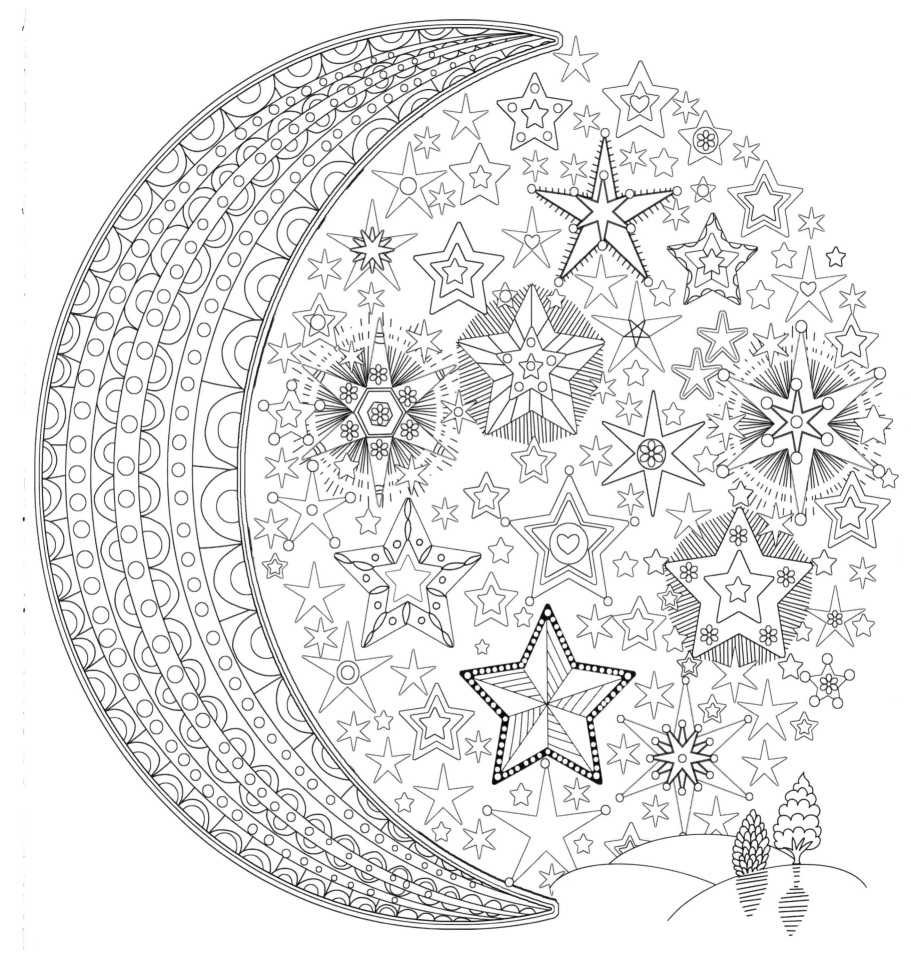

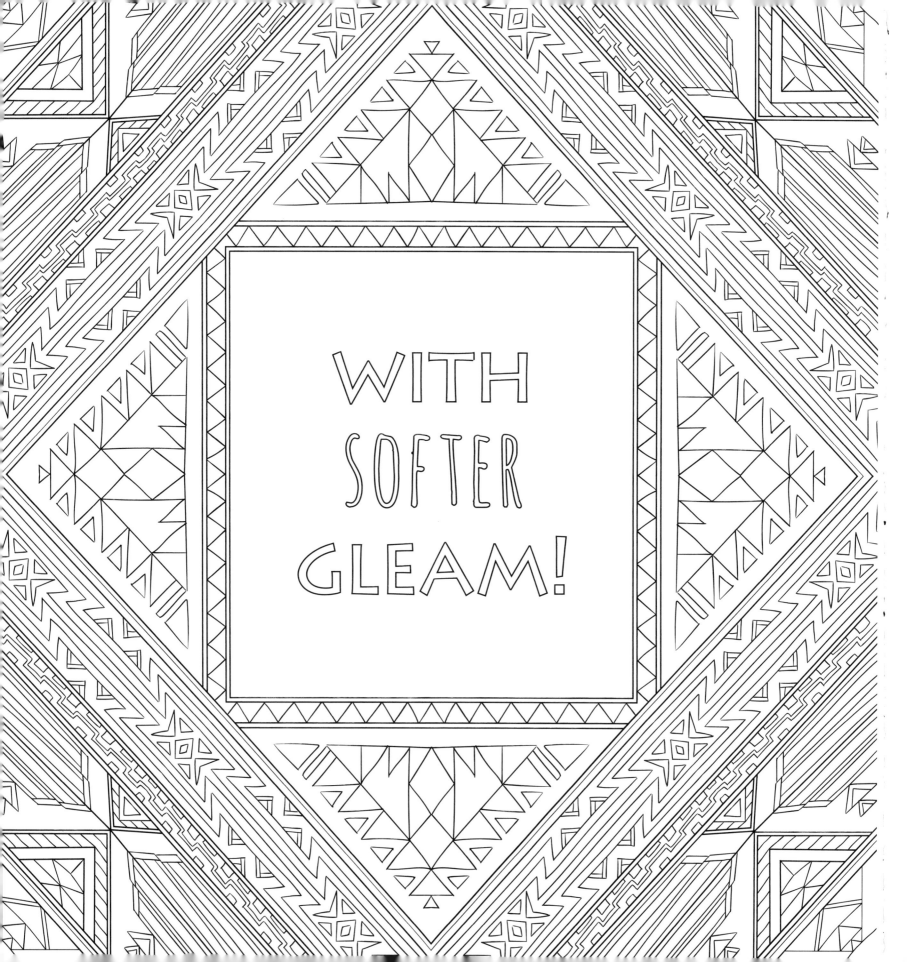

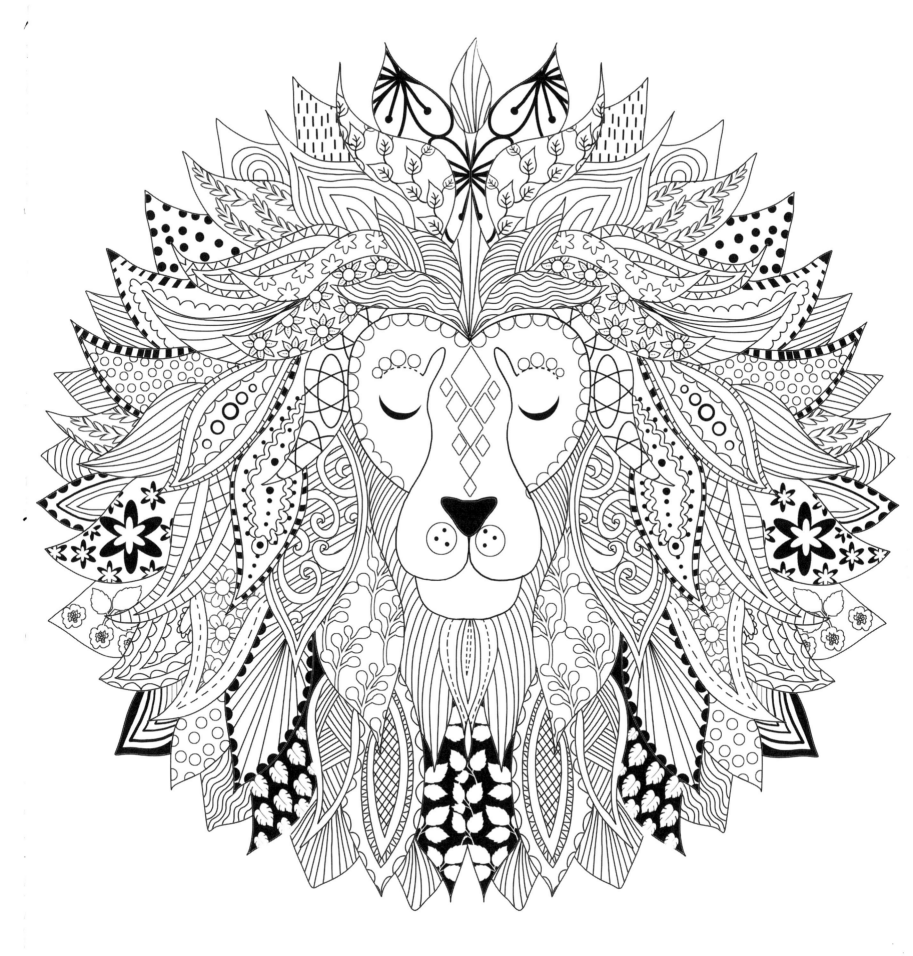

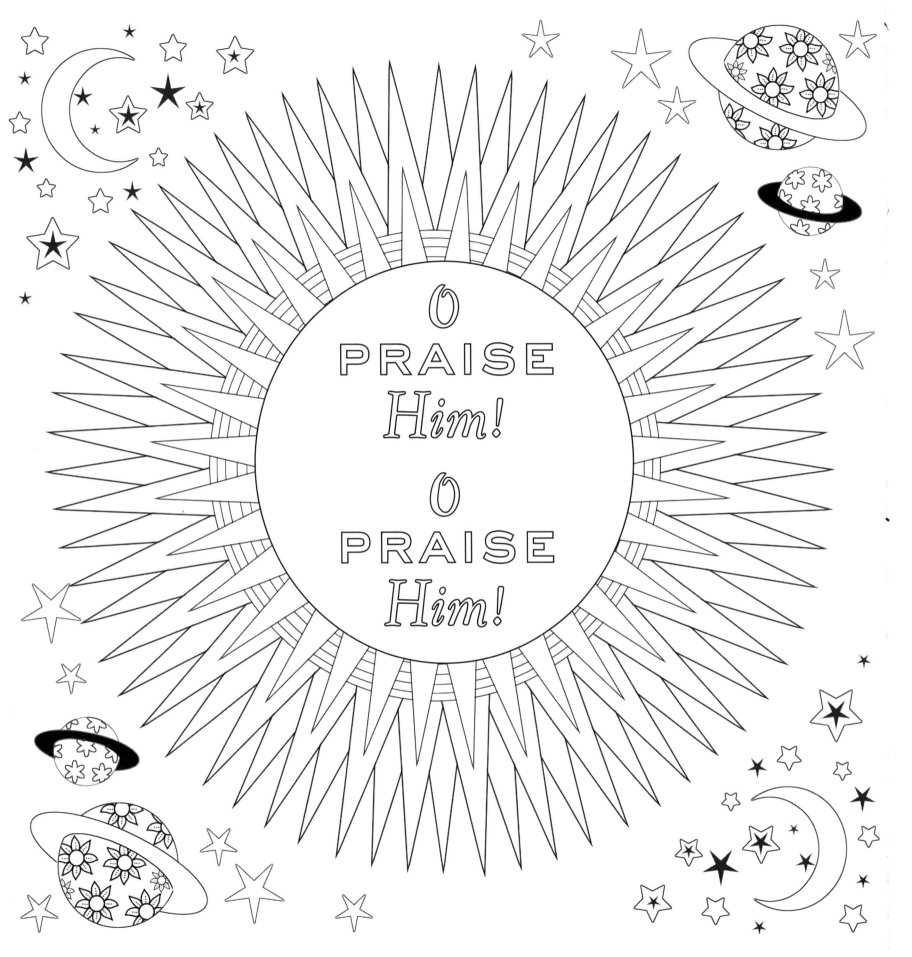

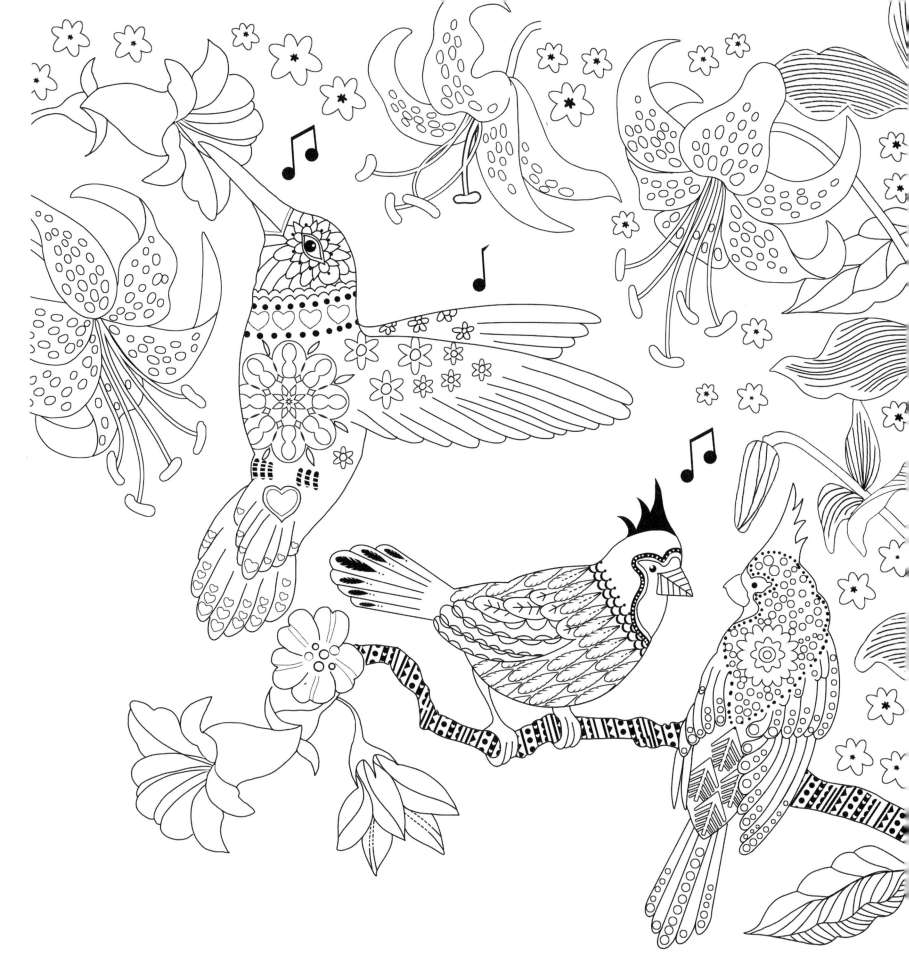

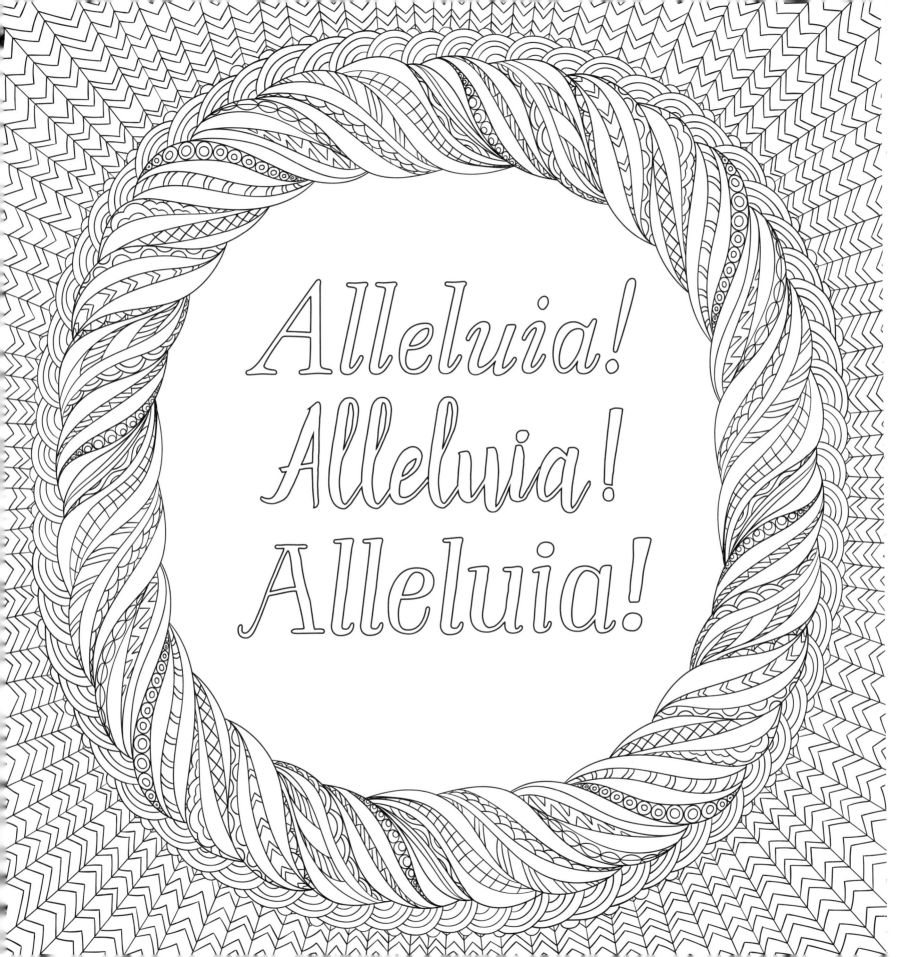

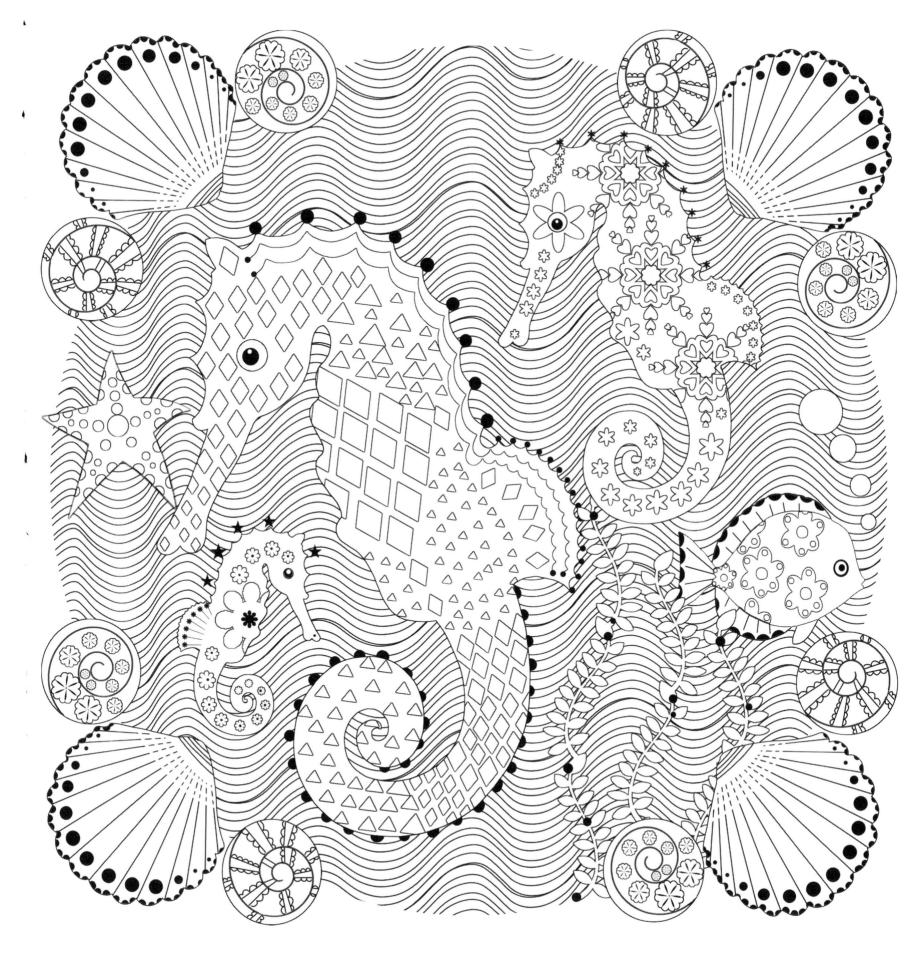

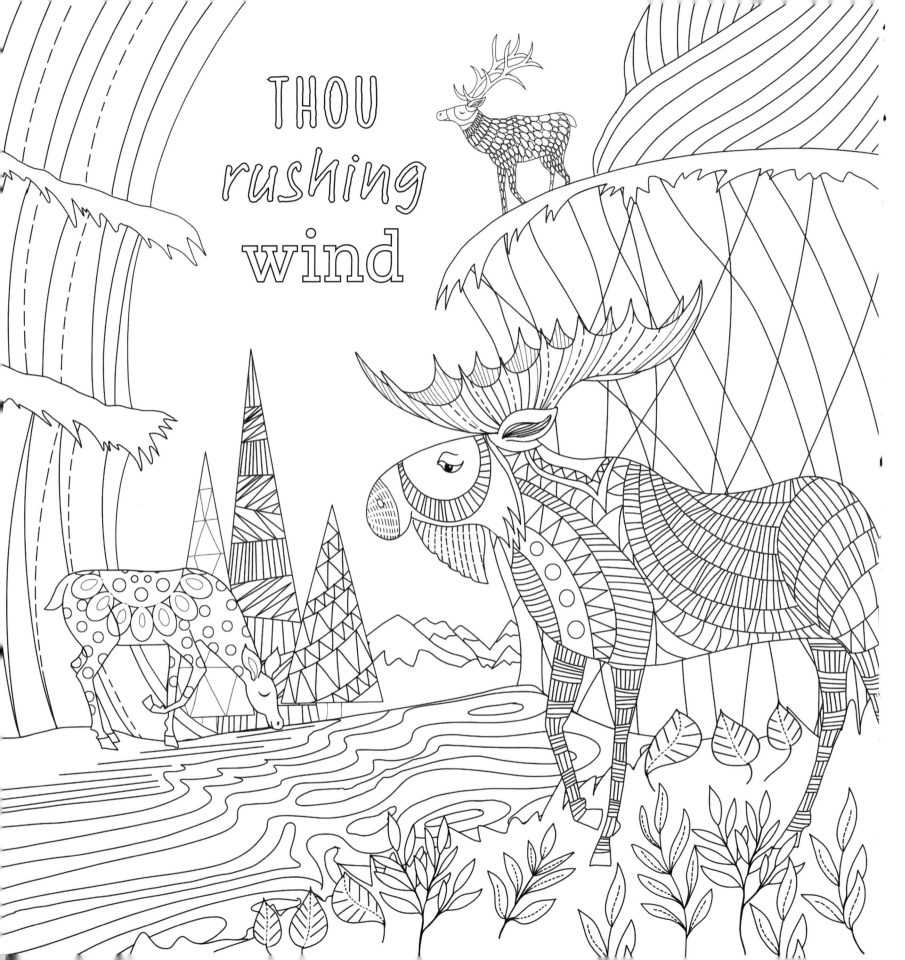

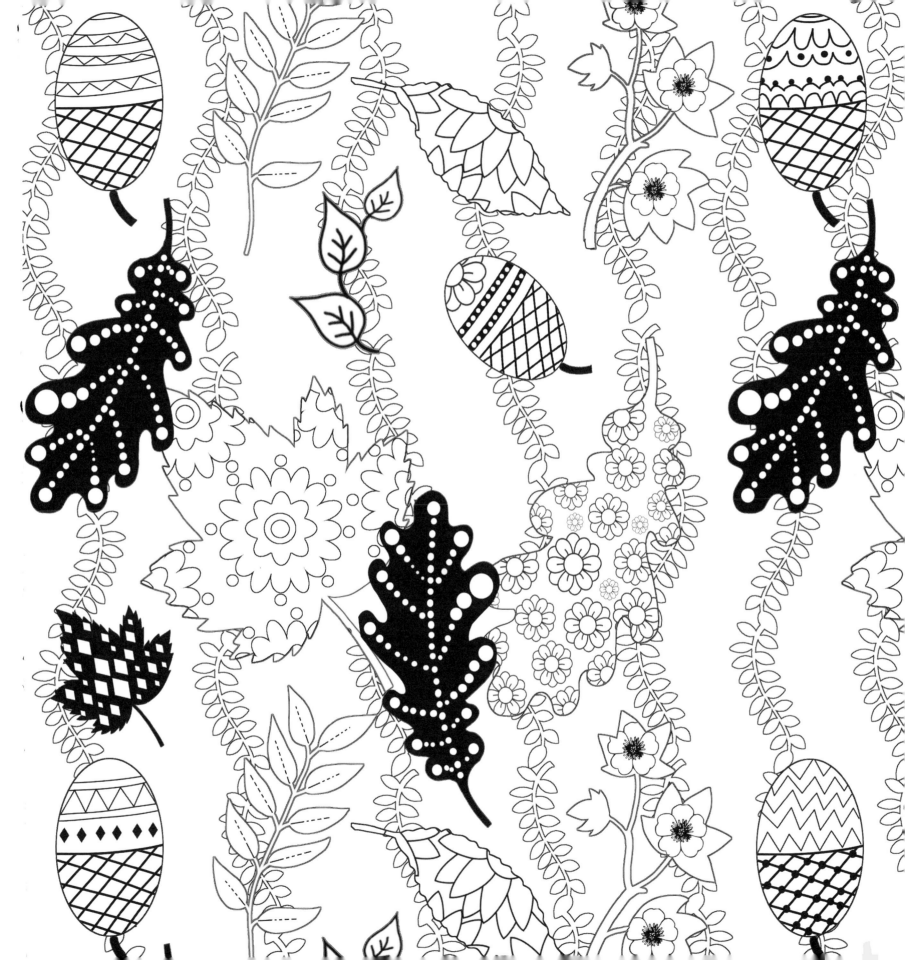

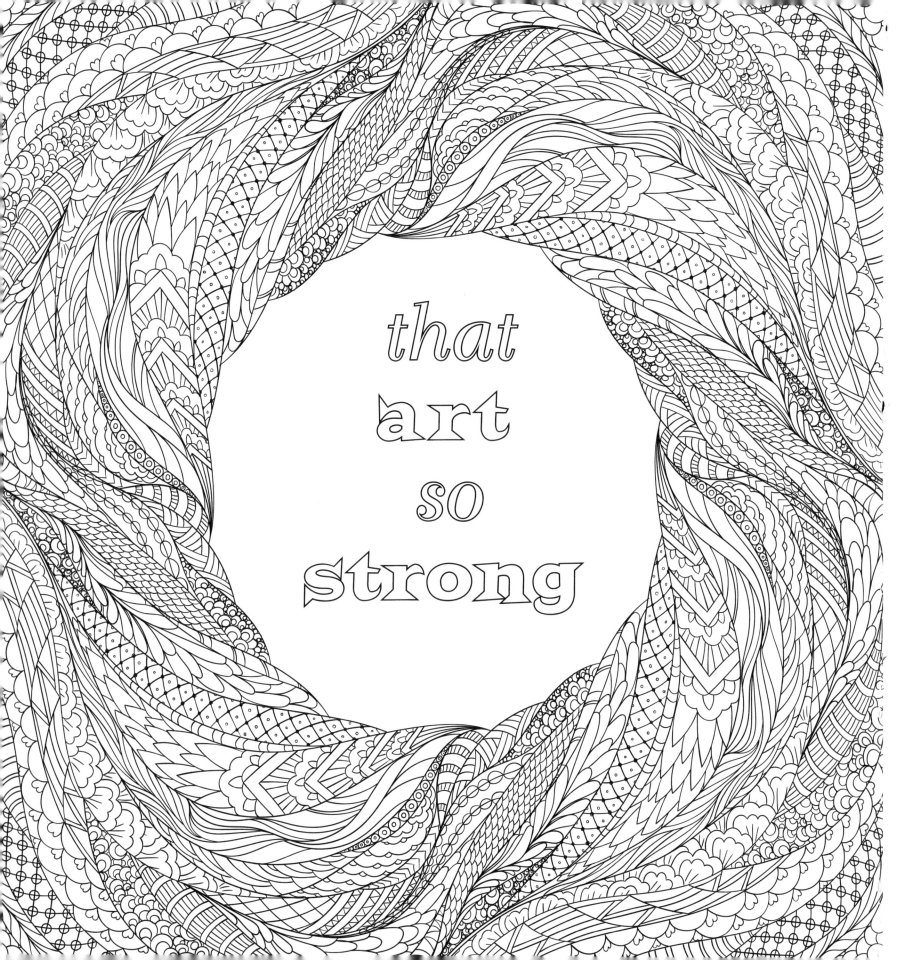

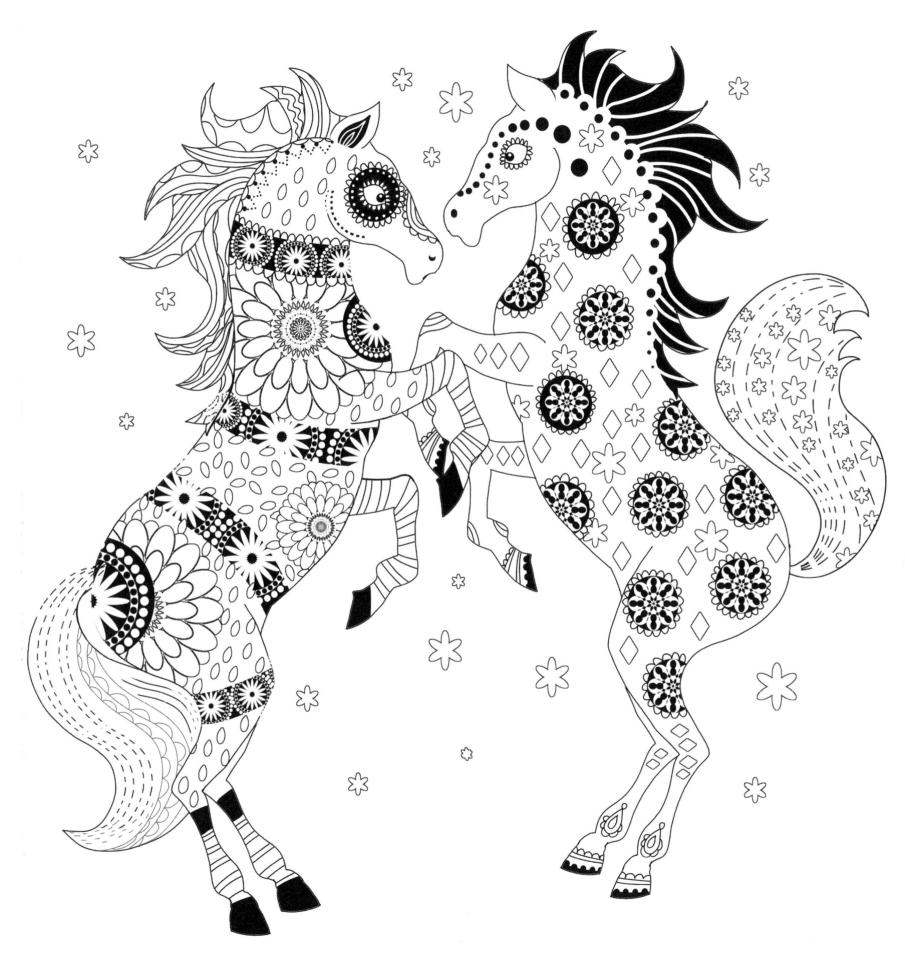

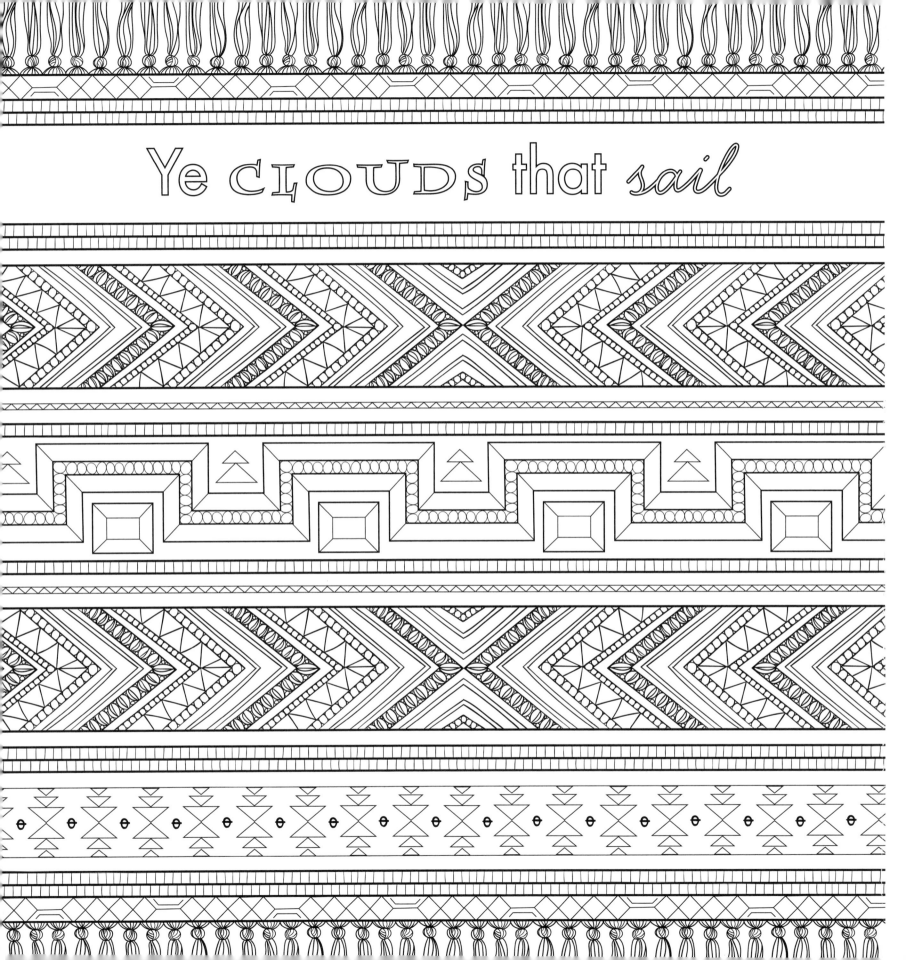

Ye CLOUDS that *sail*

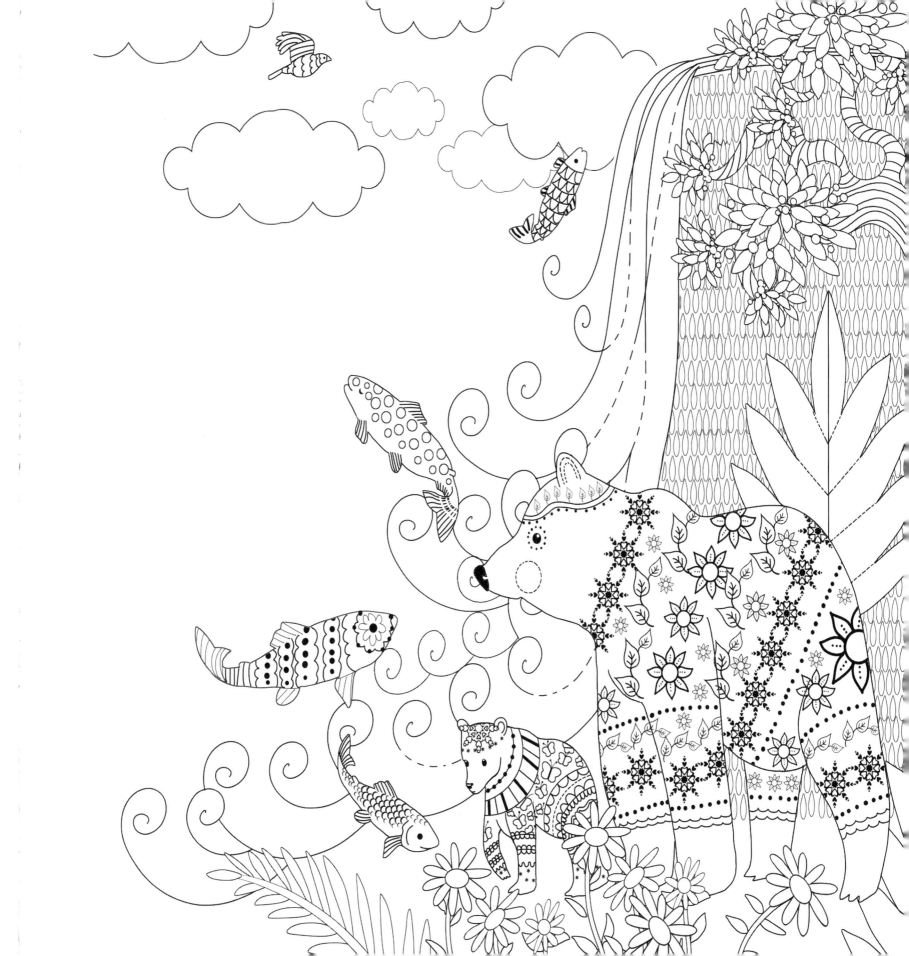

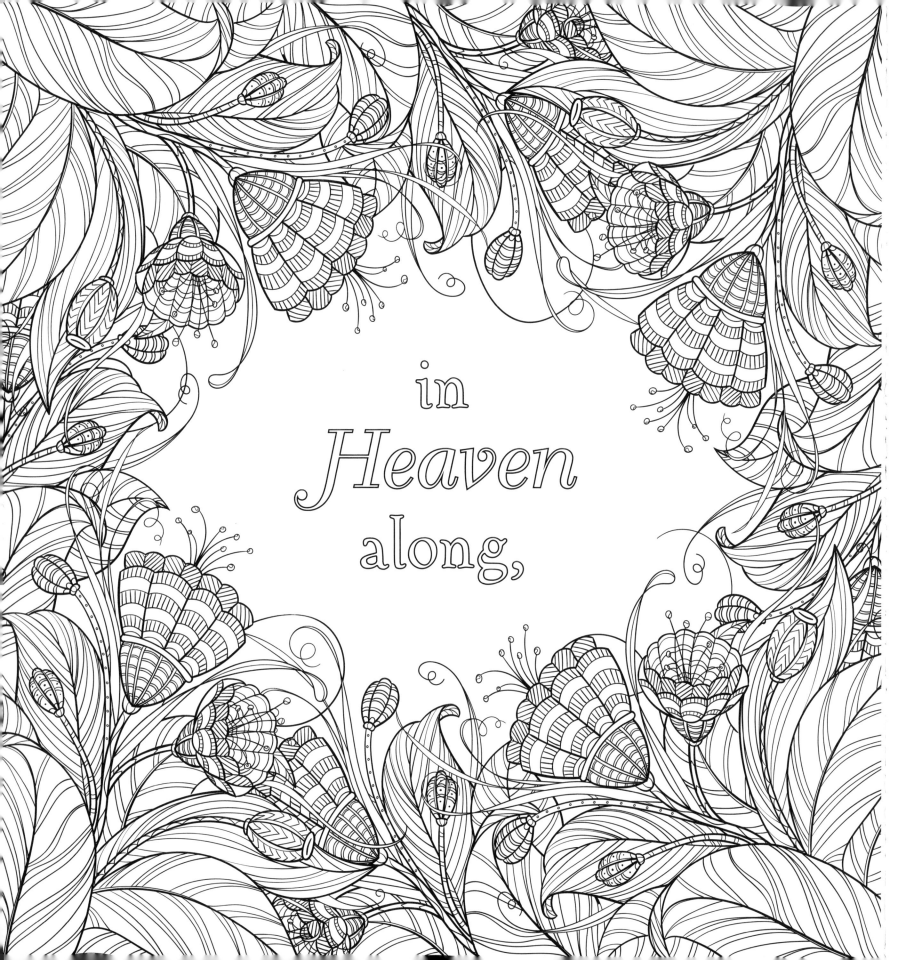

in
Heaven
along,

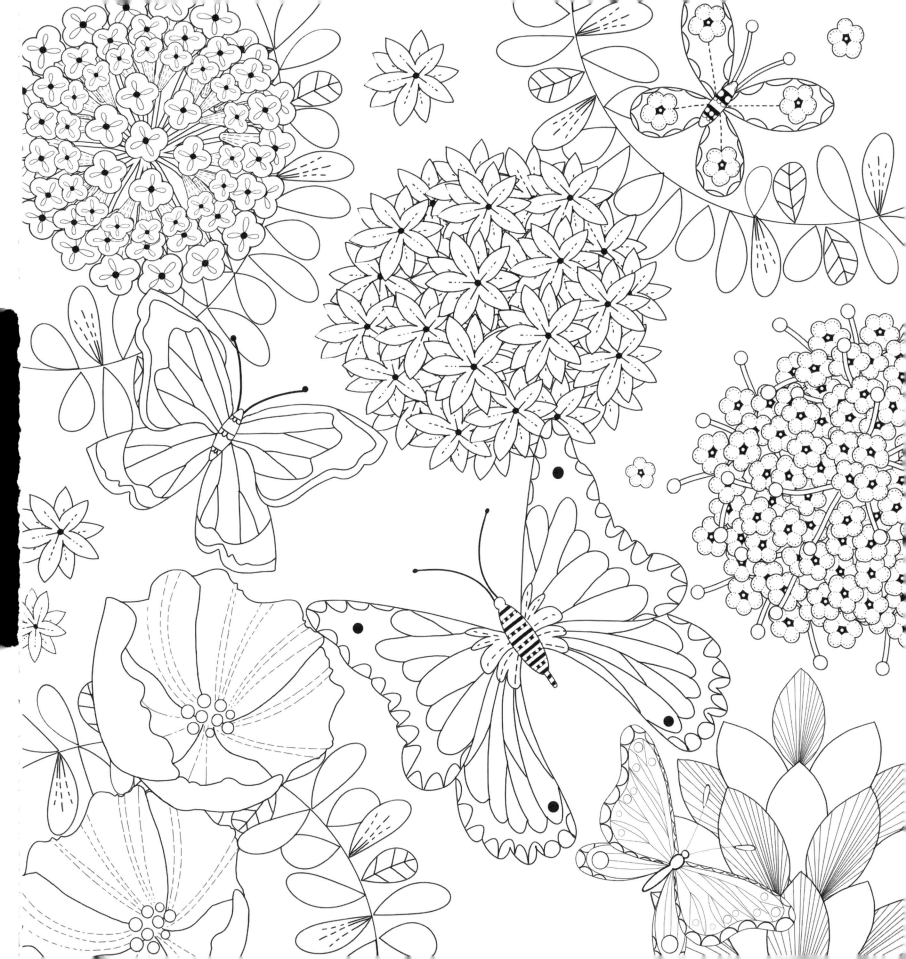

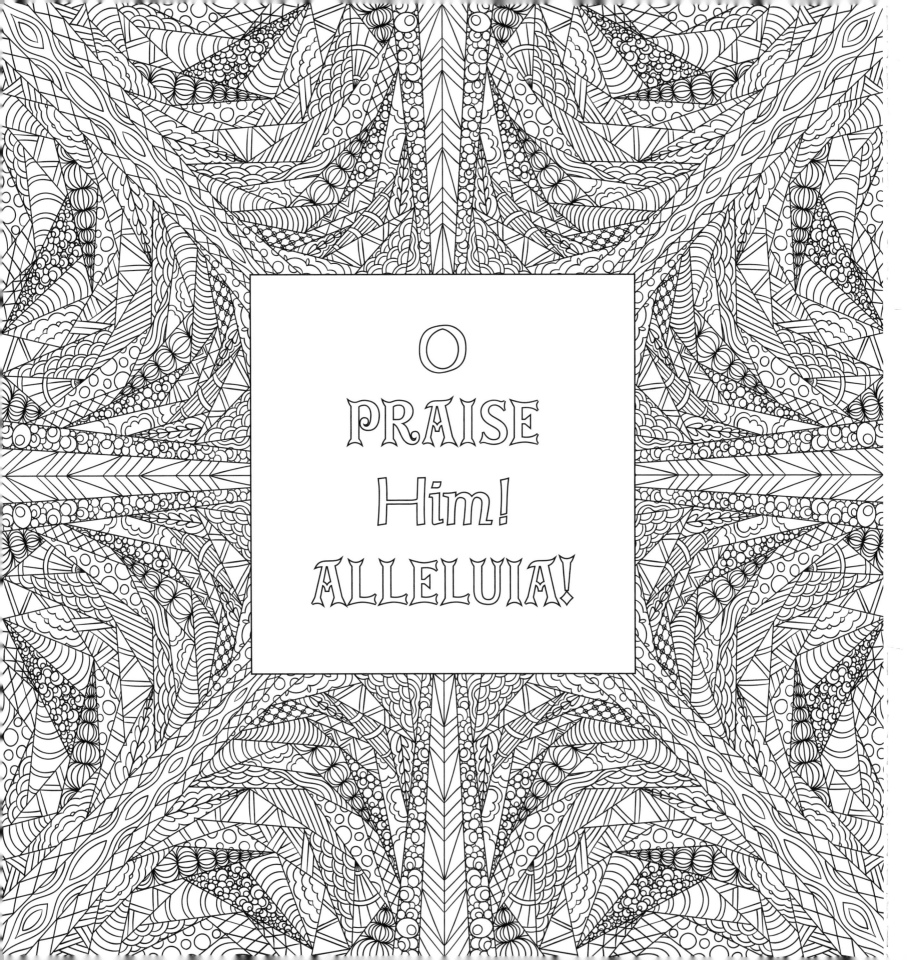

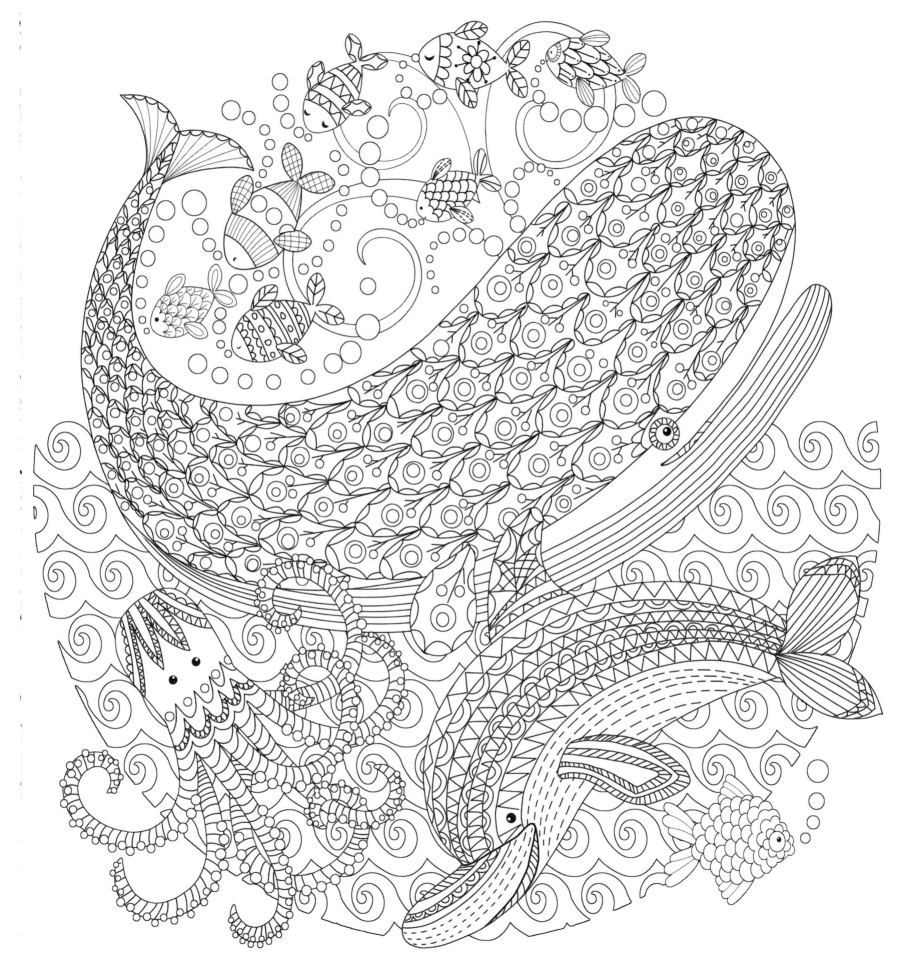

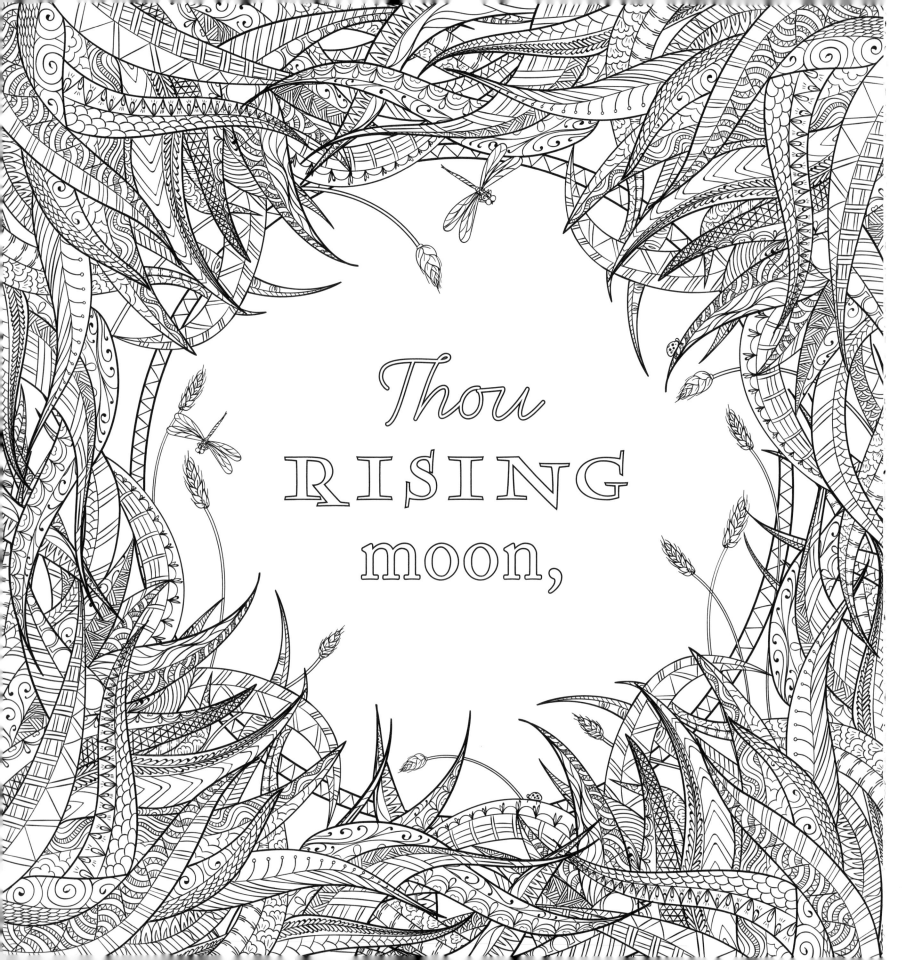

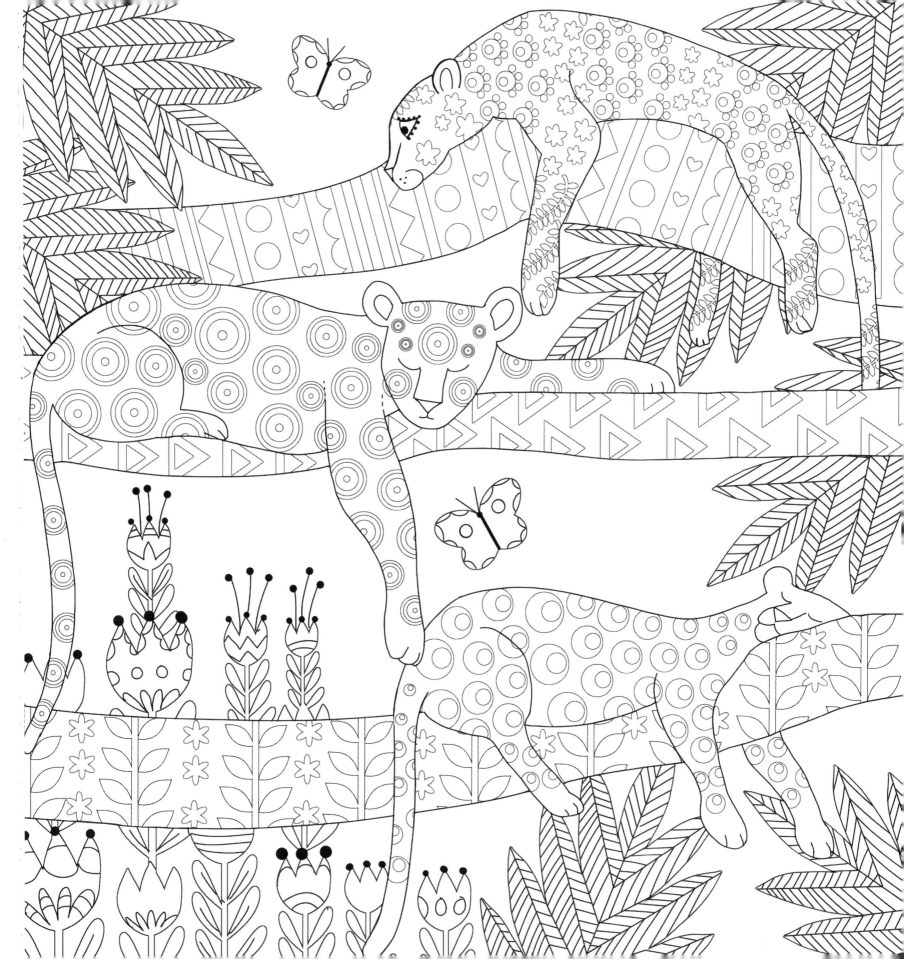

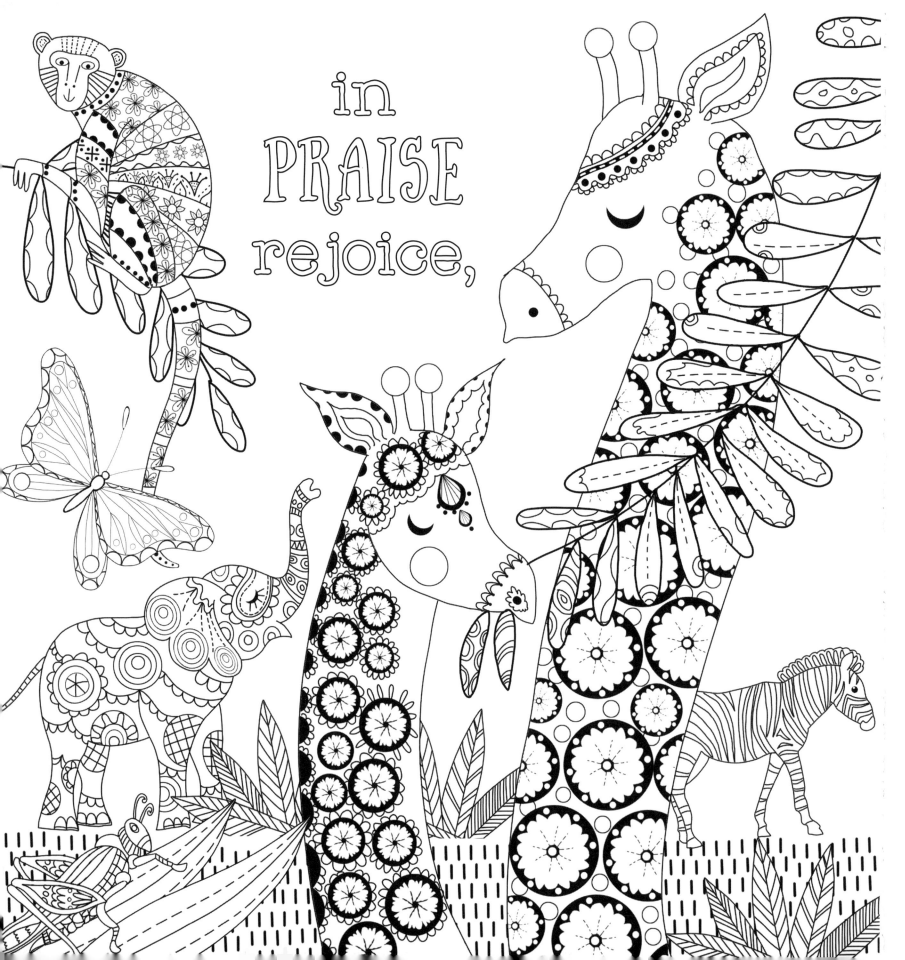

in PRAISE rejoice,

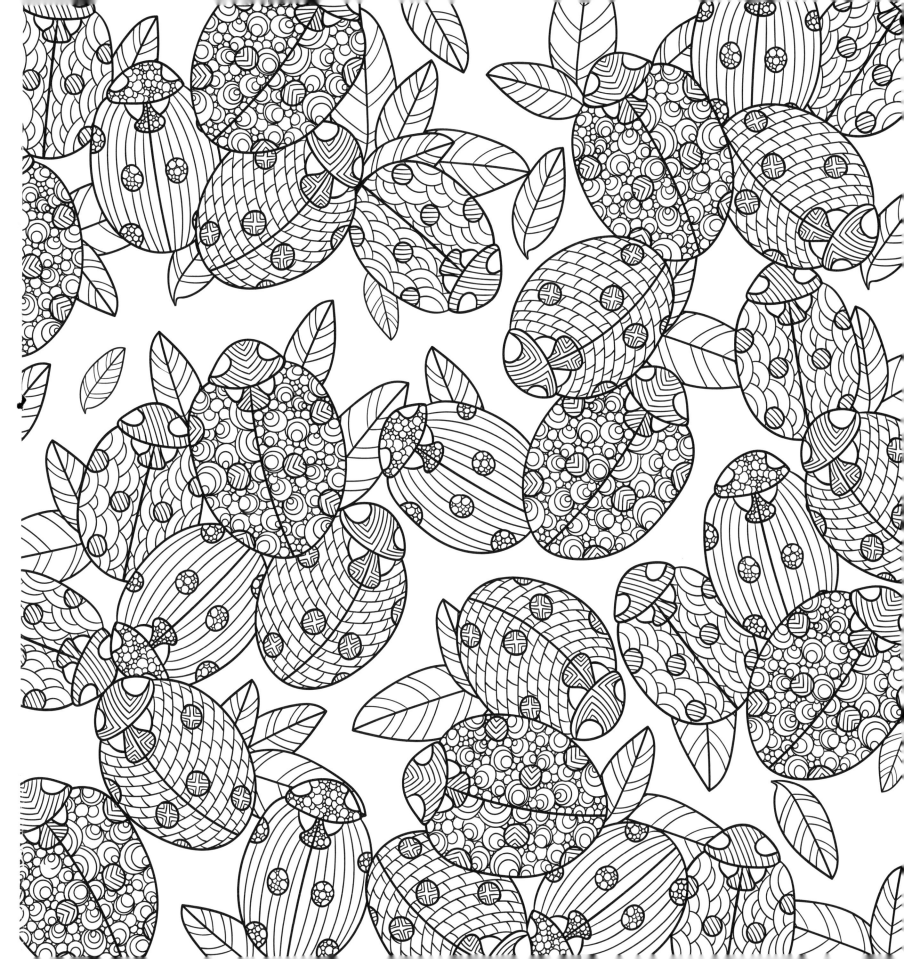

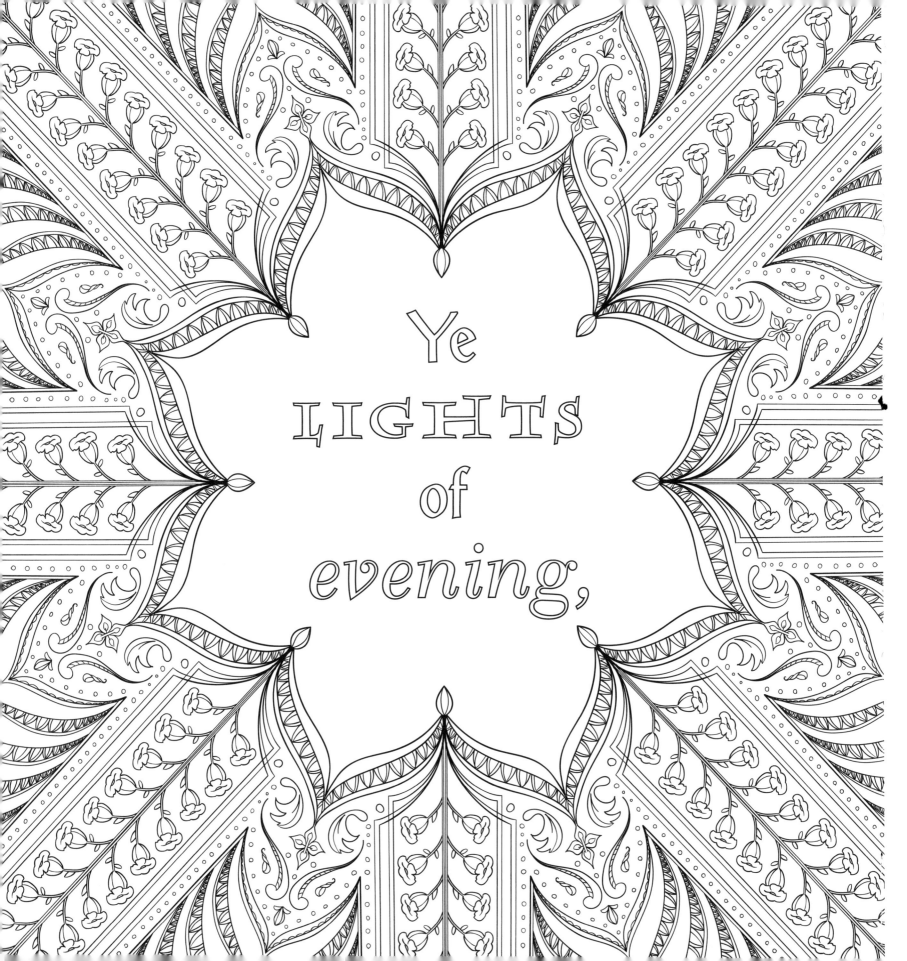

Ye LIGHTS of evening,

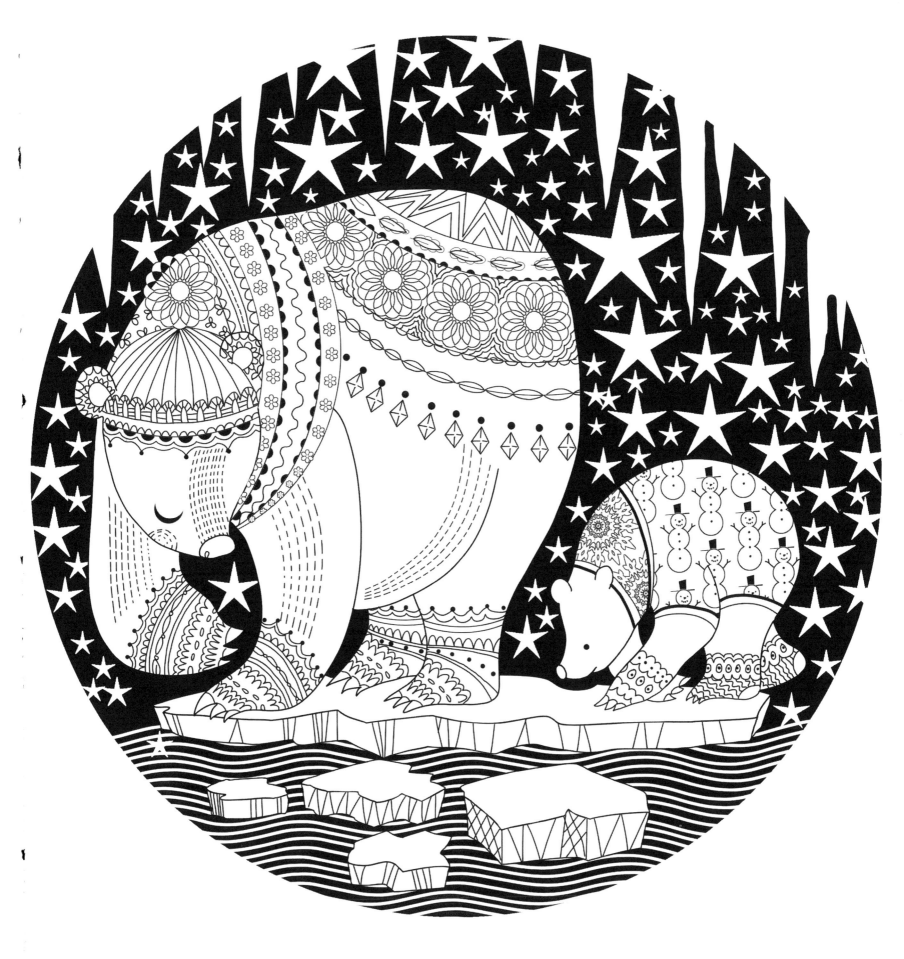

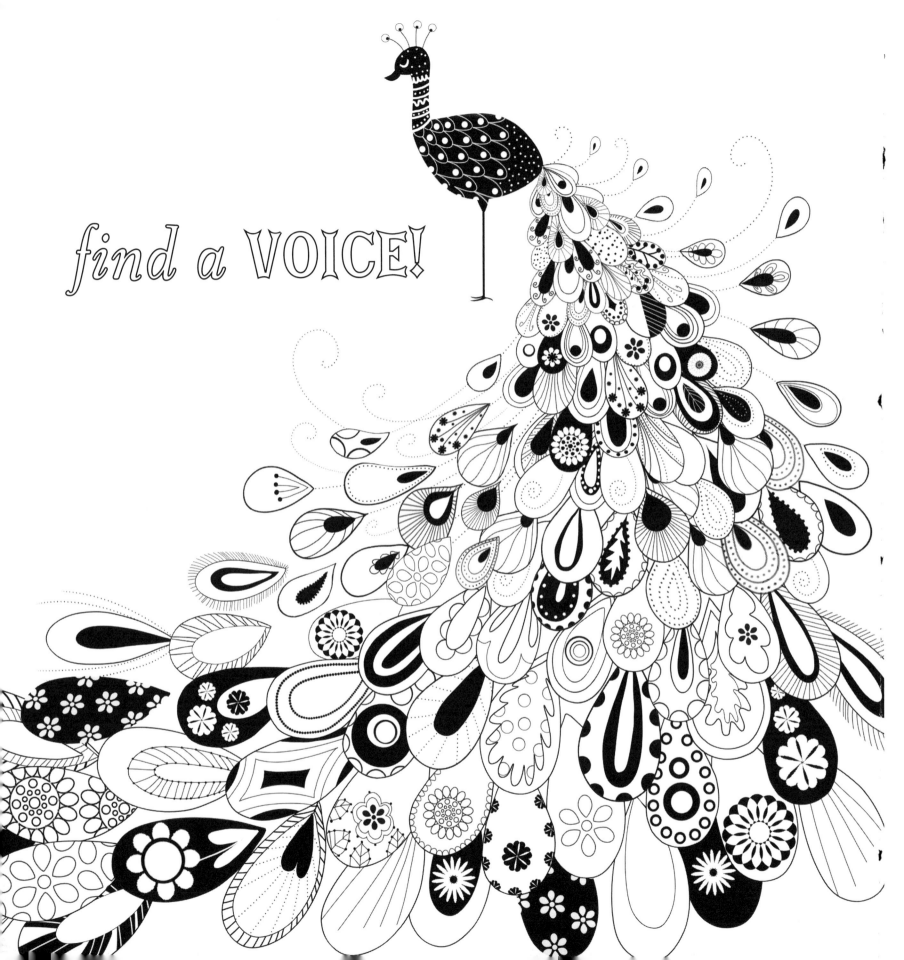

find a VOICE!

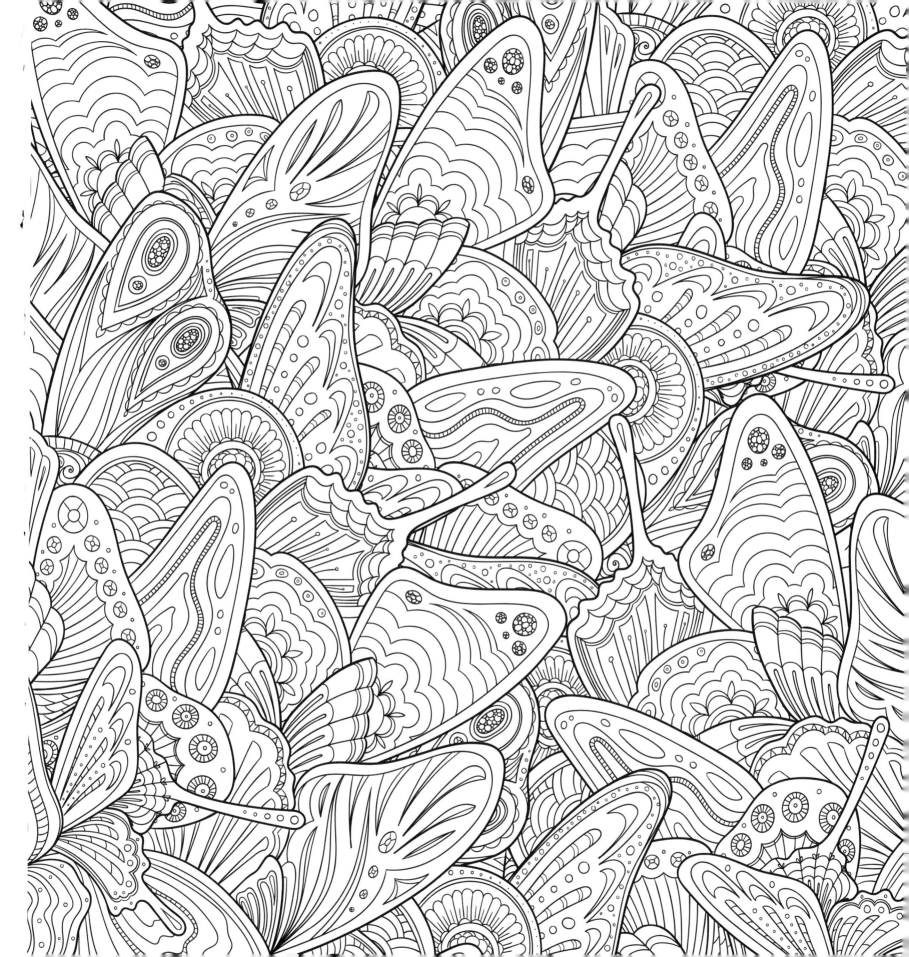

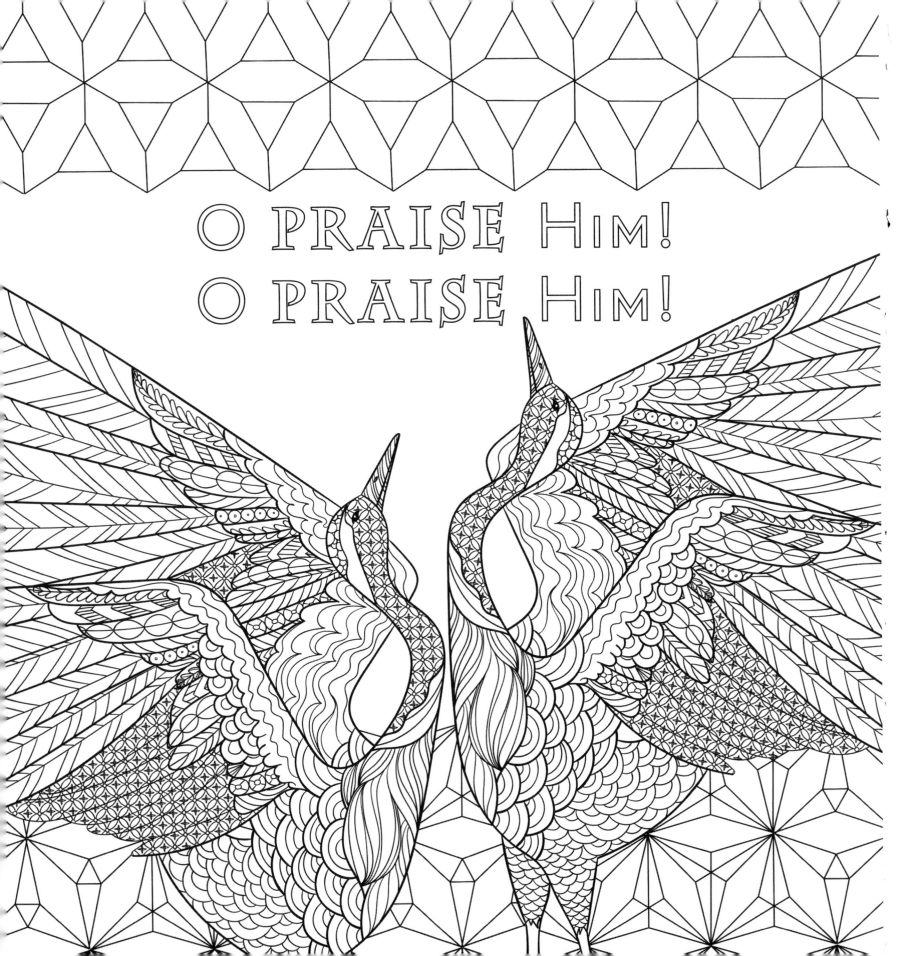

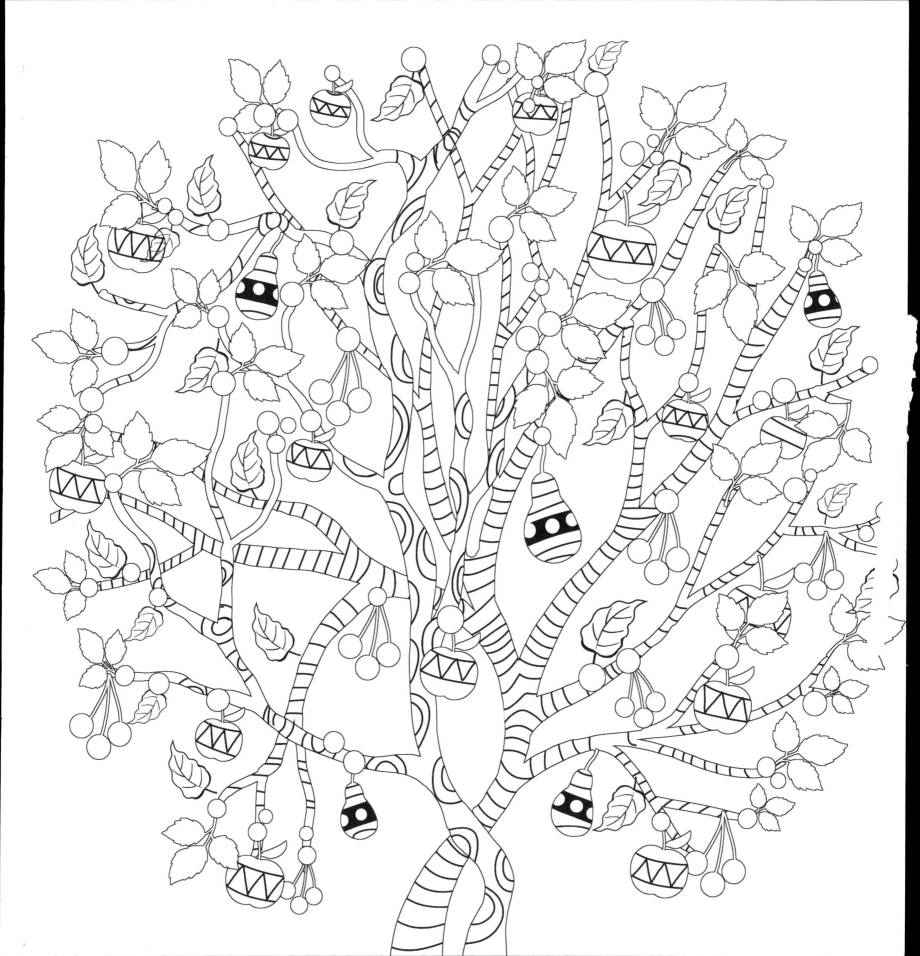

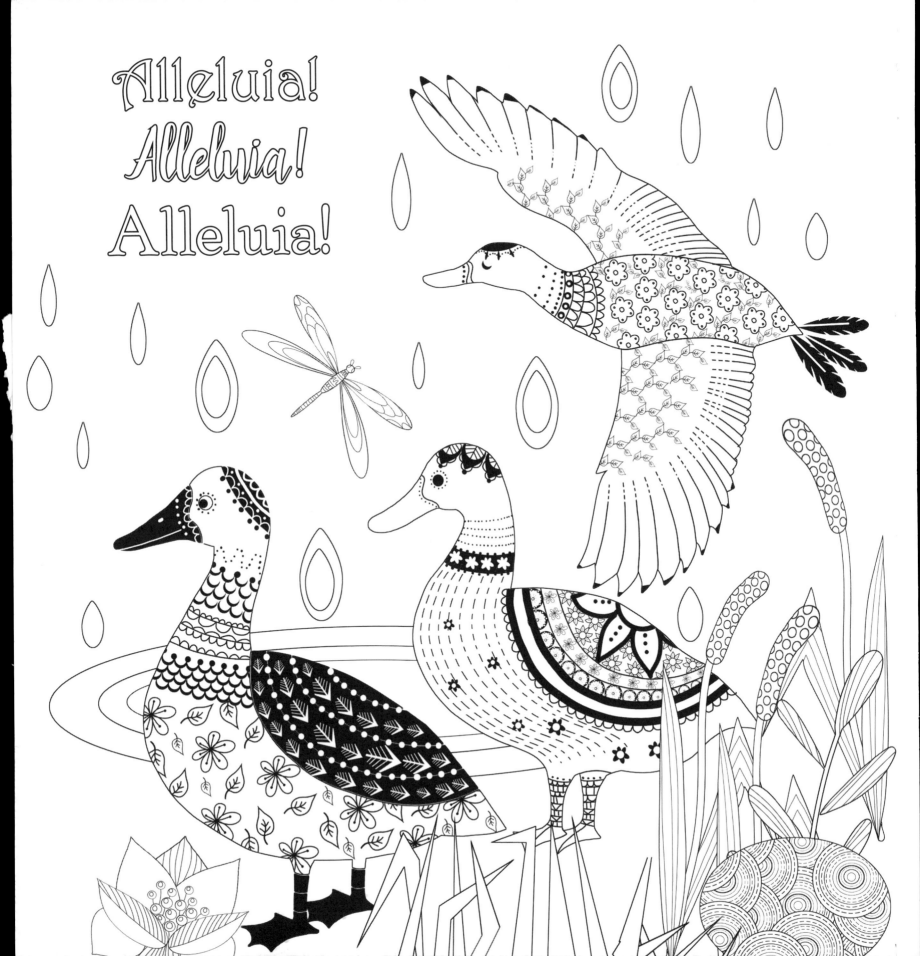

Alleluia! Alleluia! Alleluia!

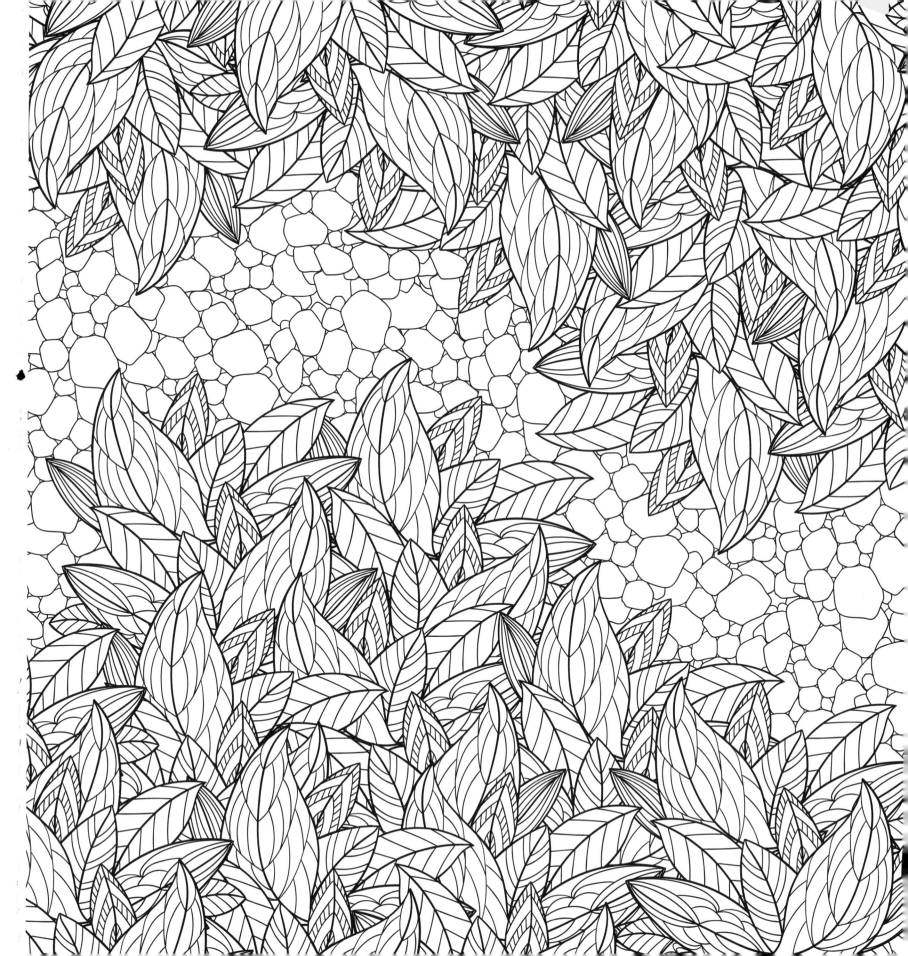

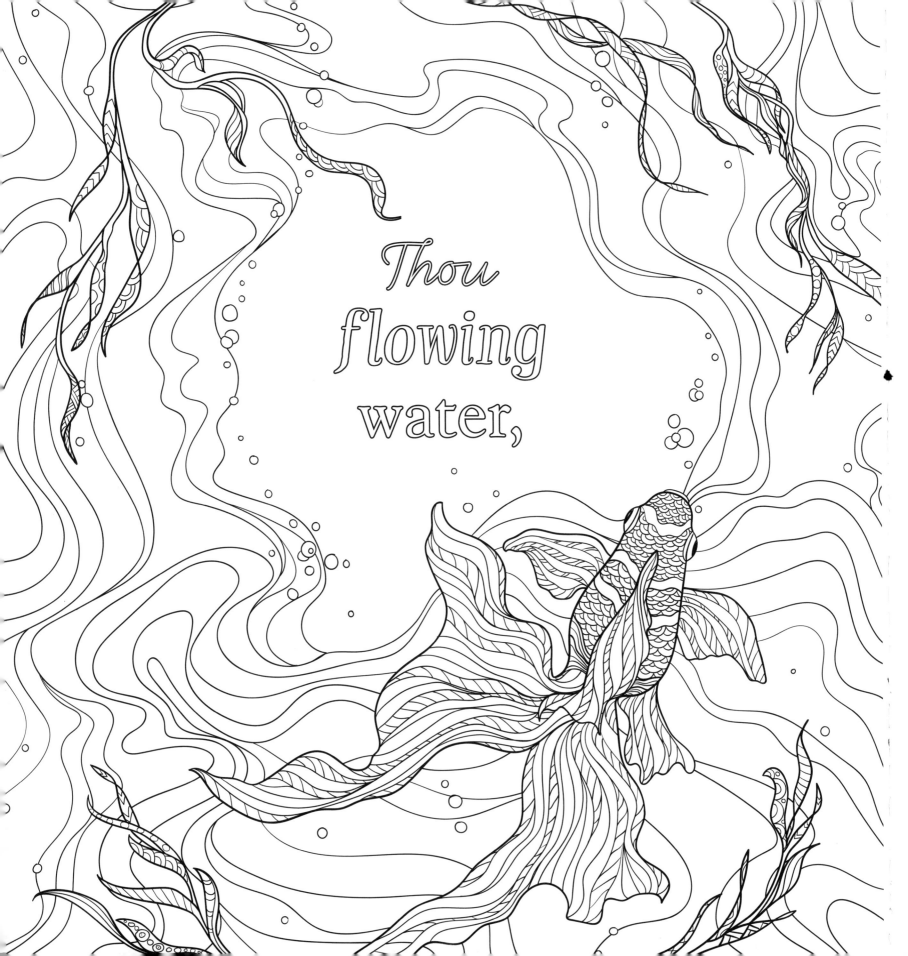

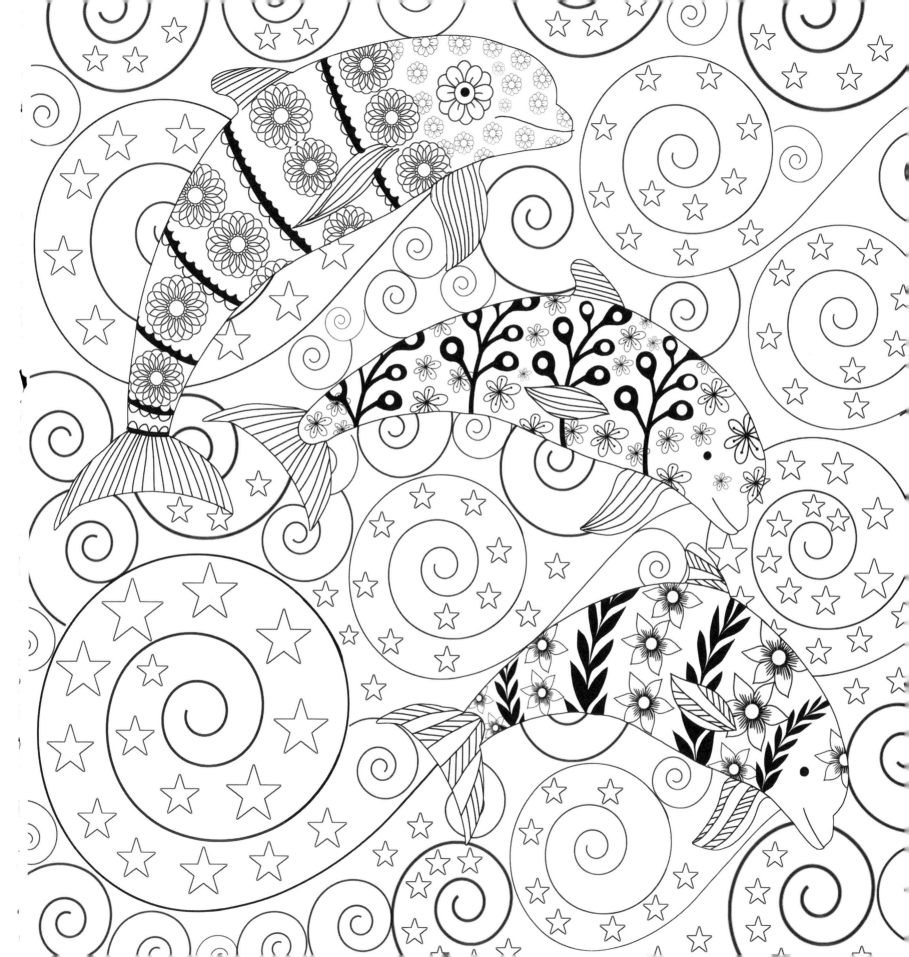

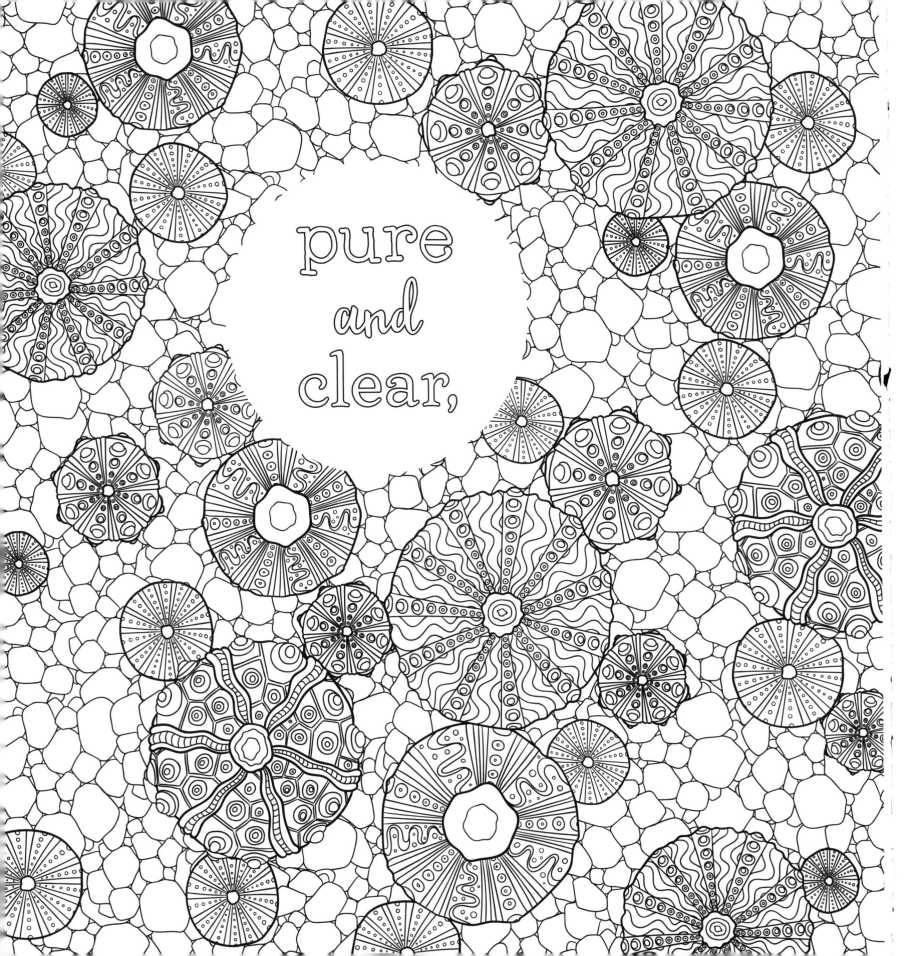

pure
and
clear,

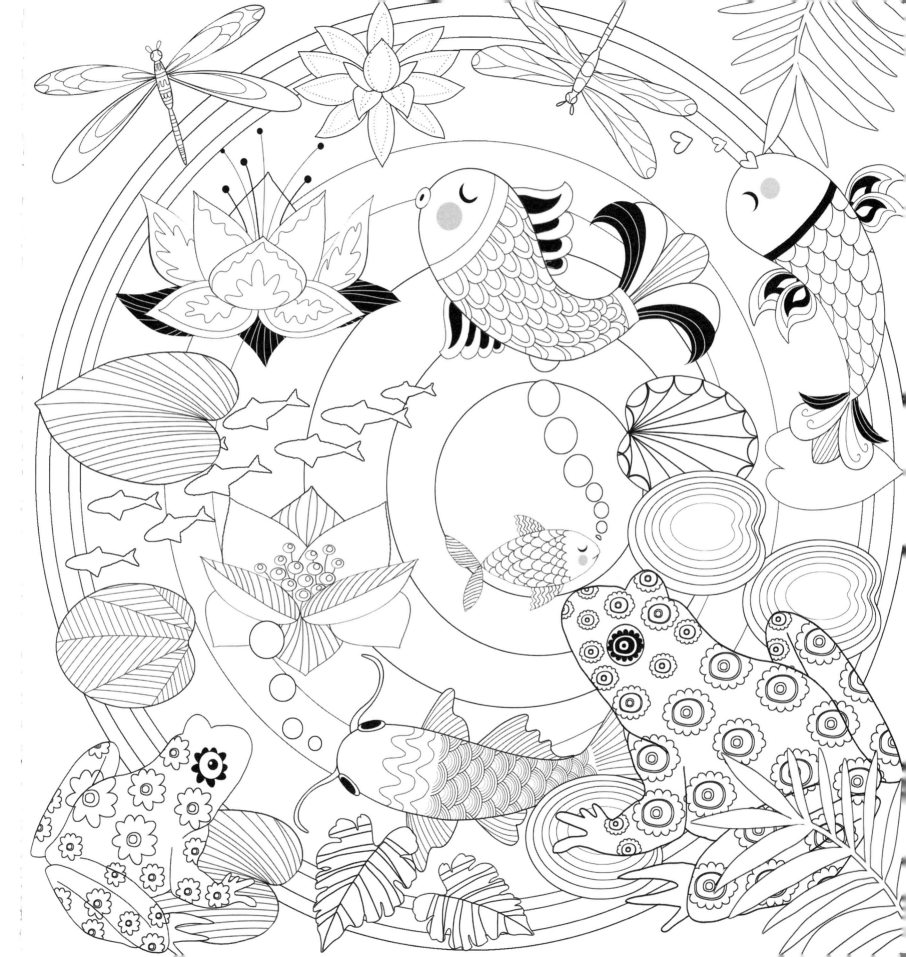

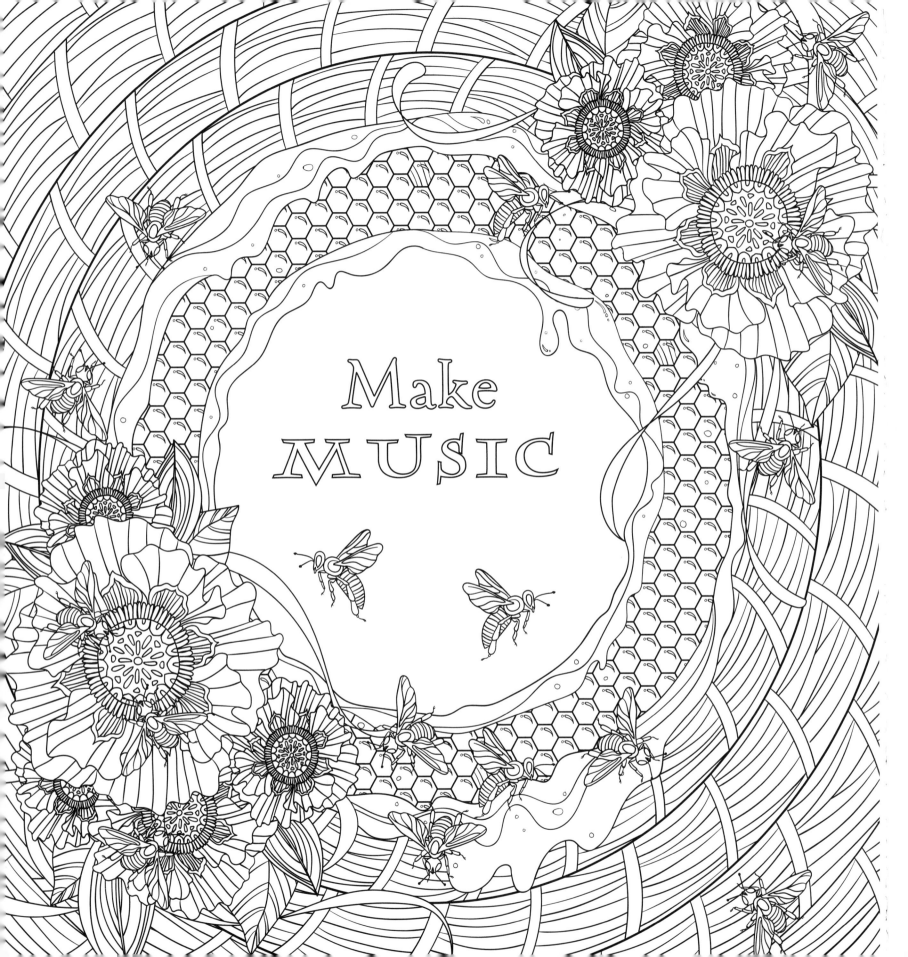

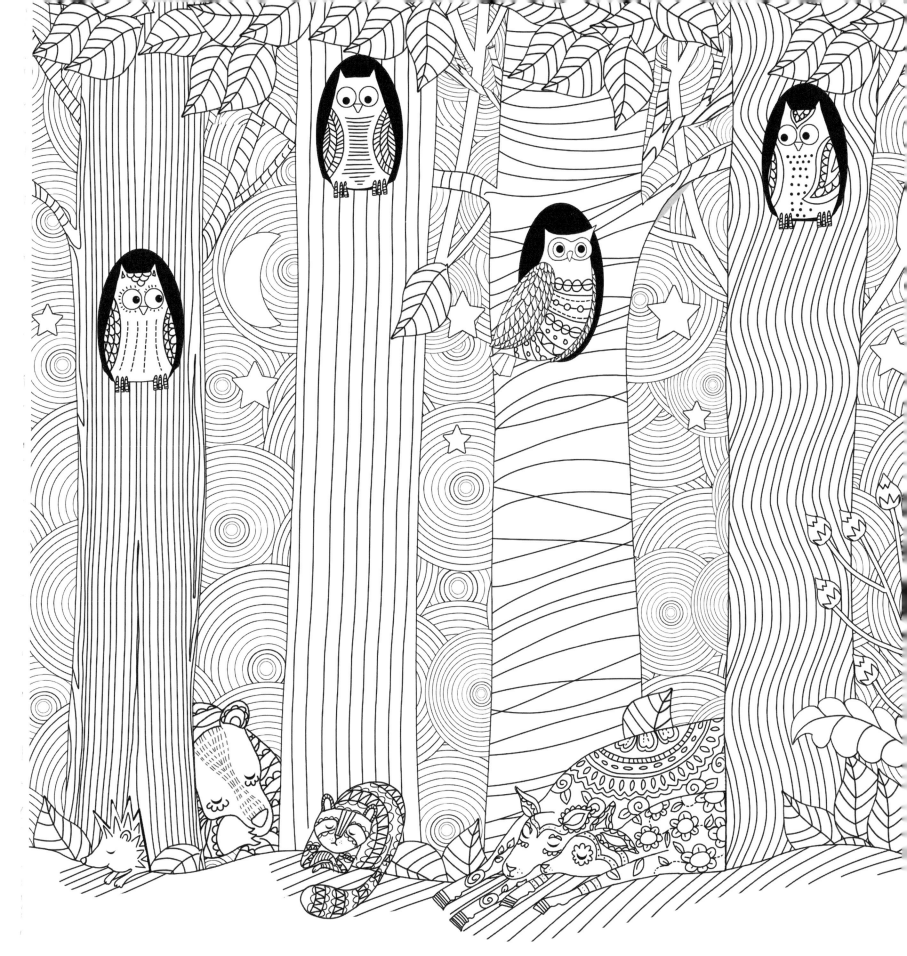

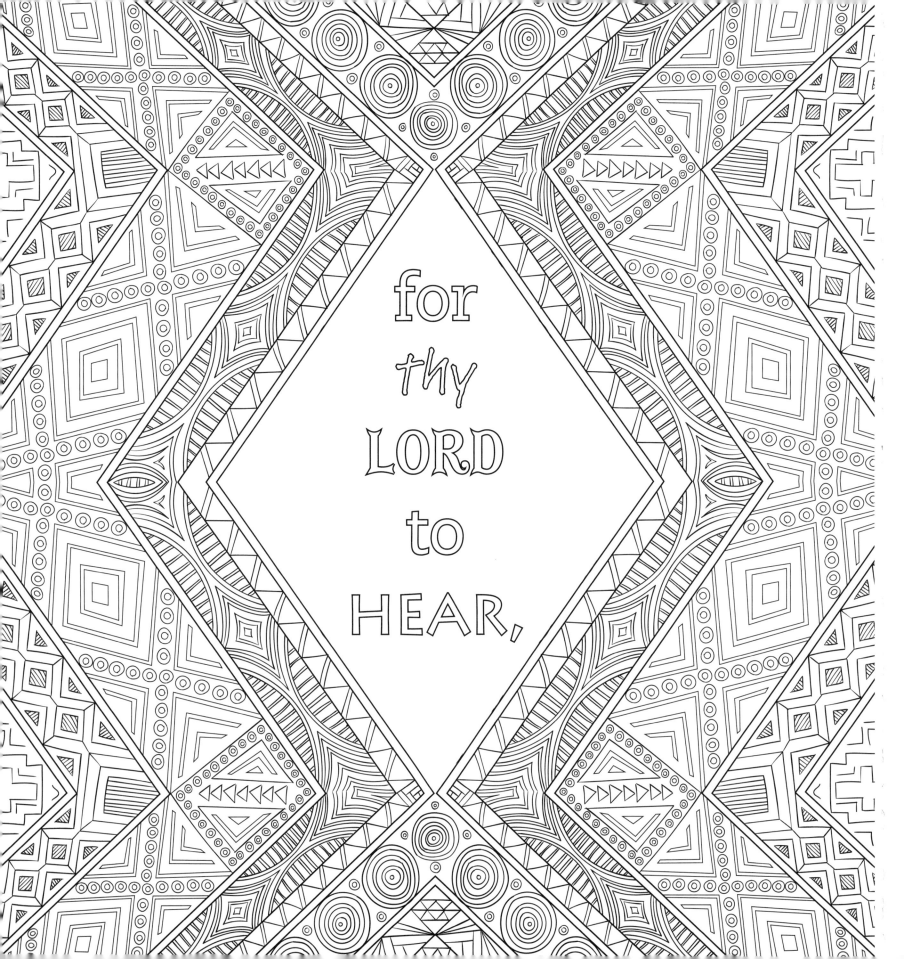

for *thy* LORD to HEAR,

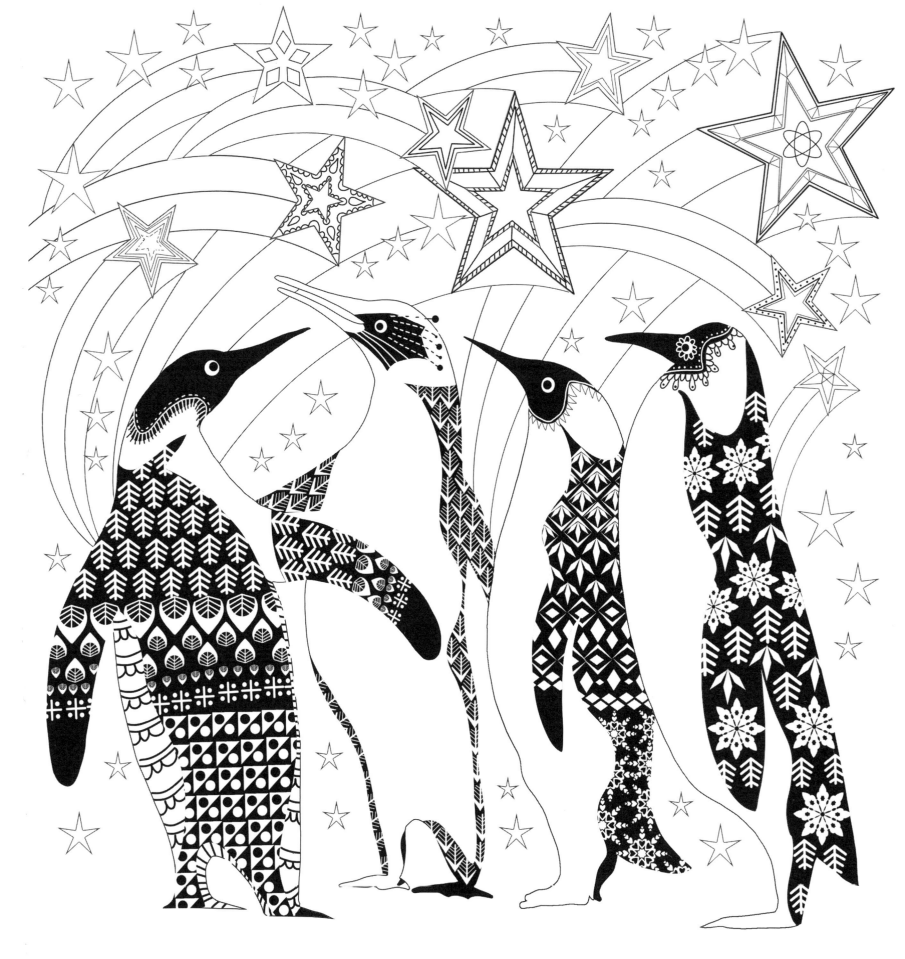

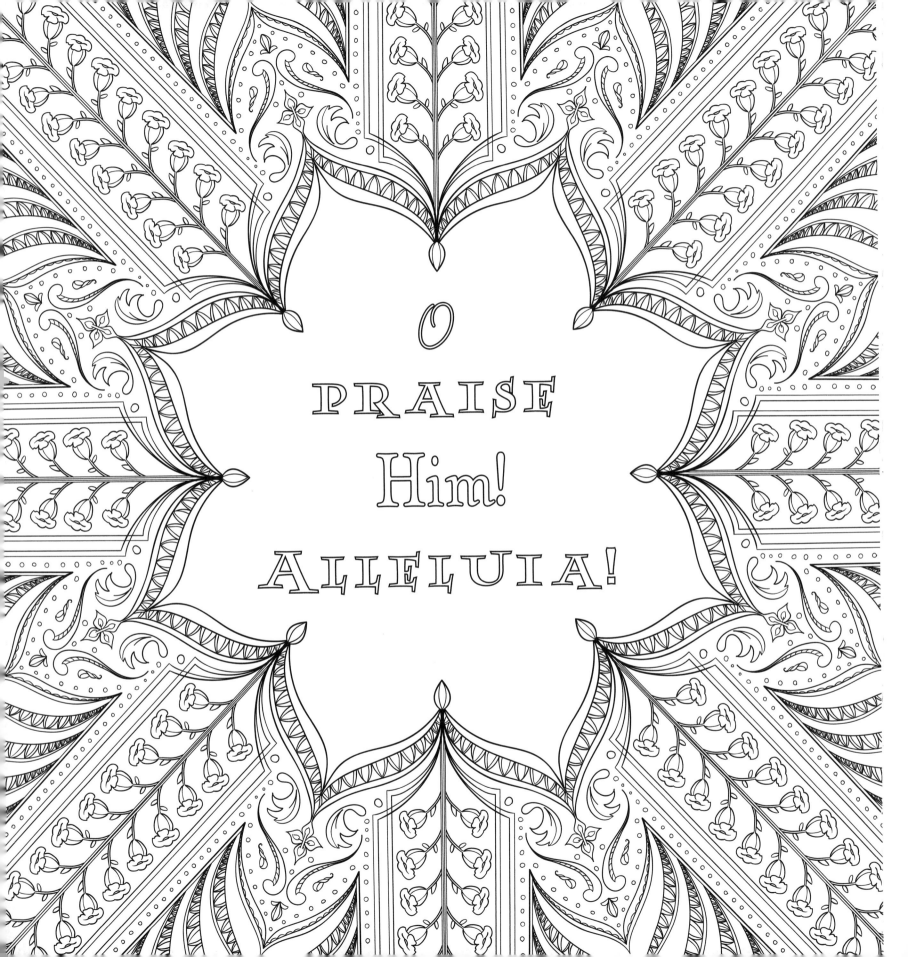

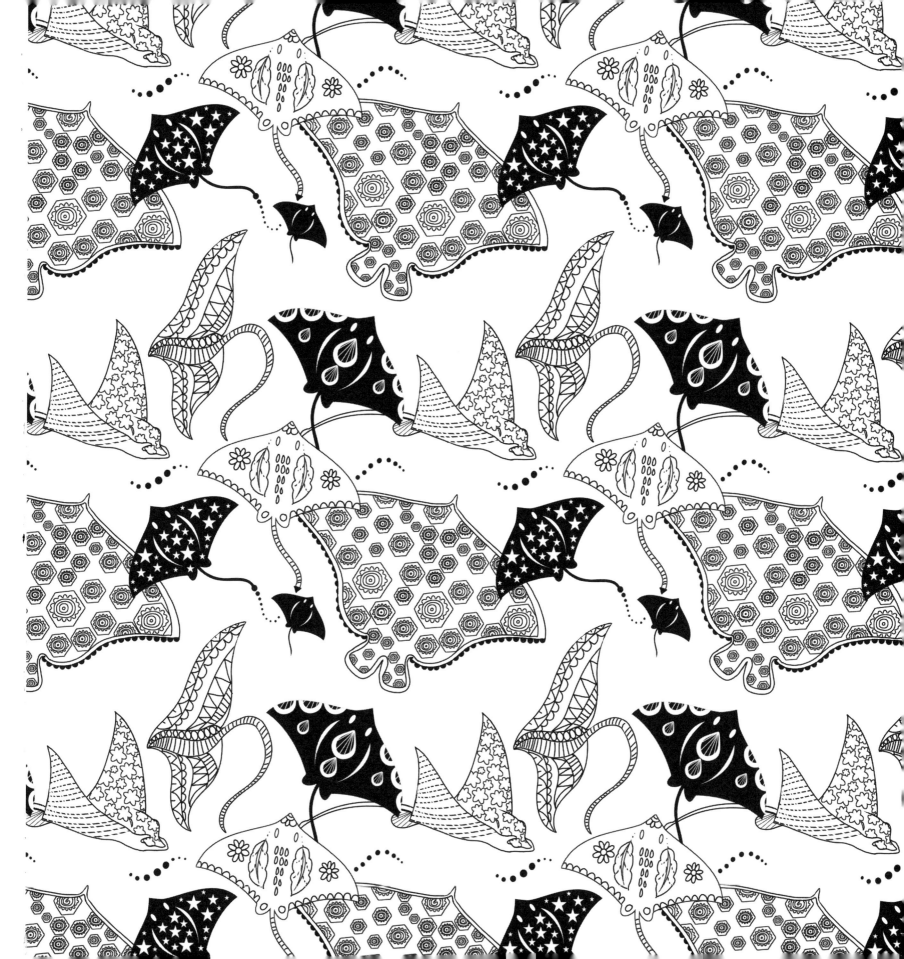

Thou FIRE

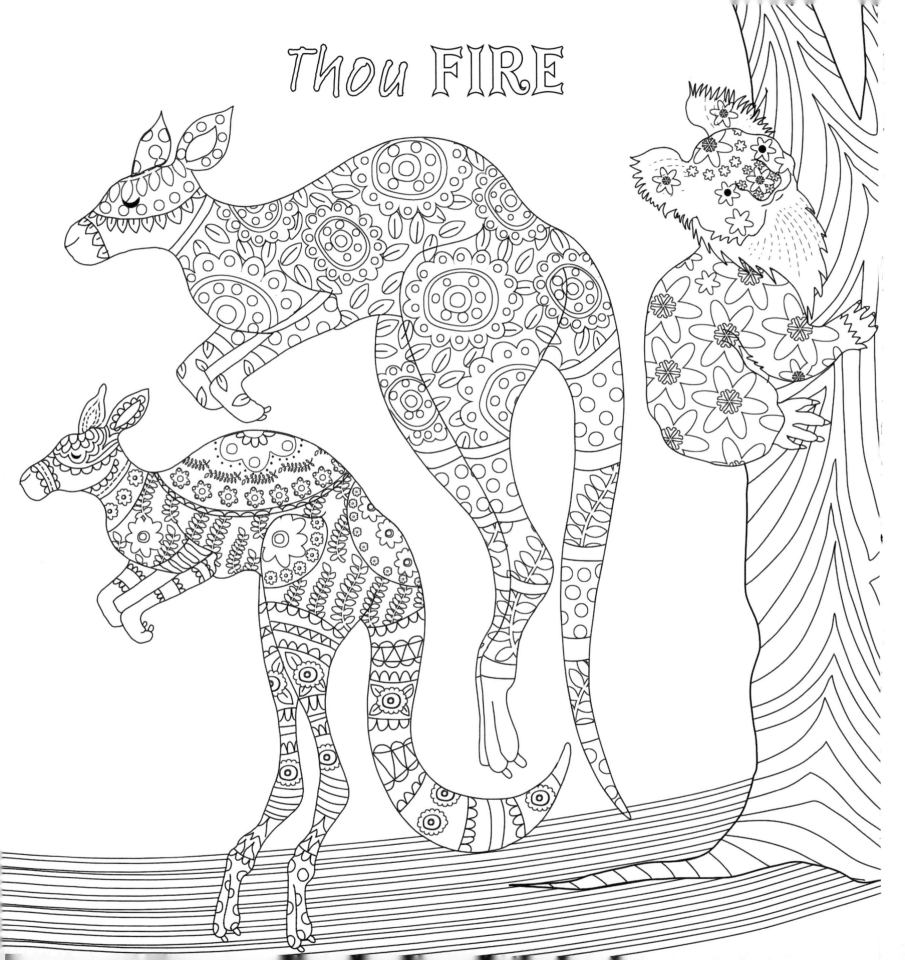

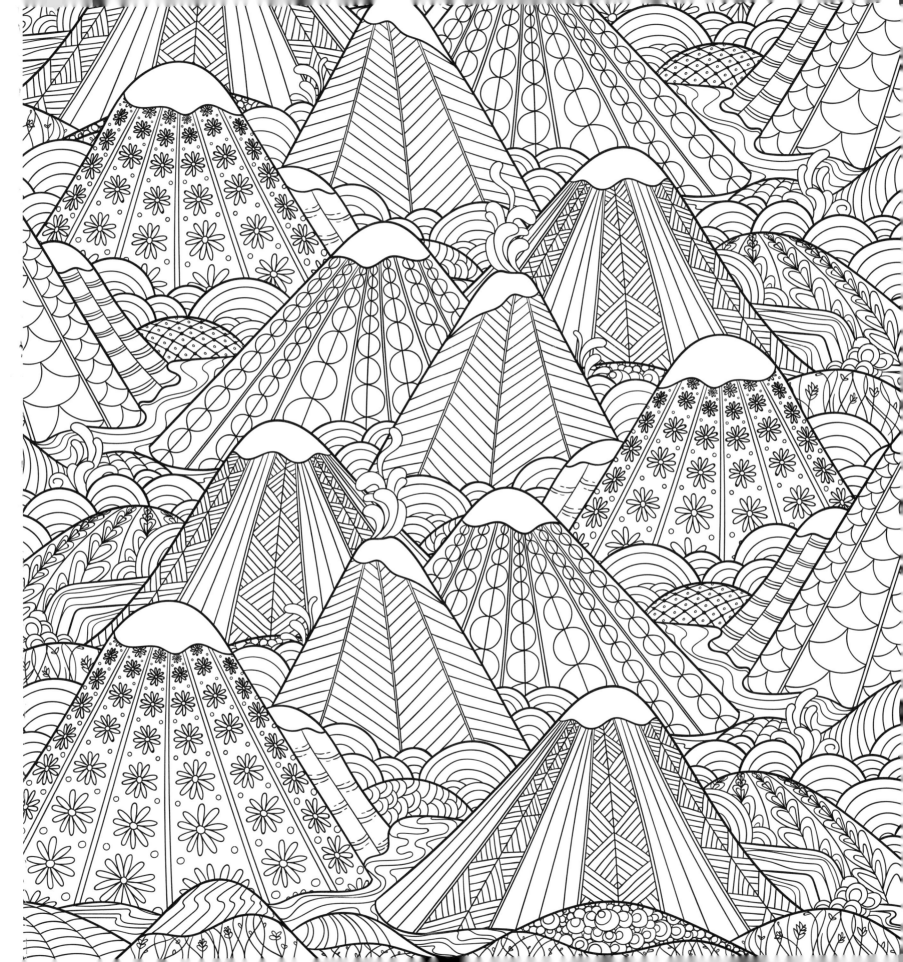

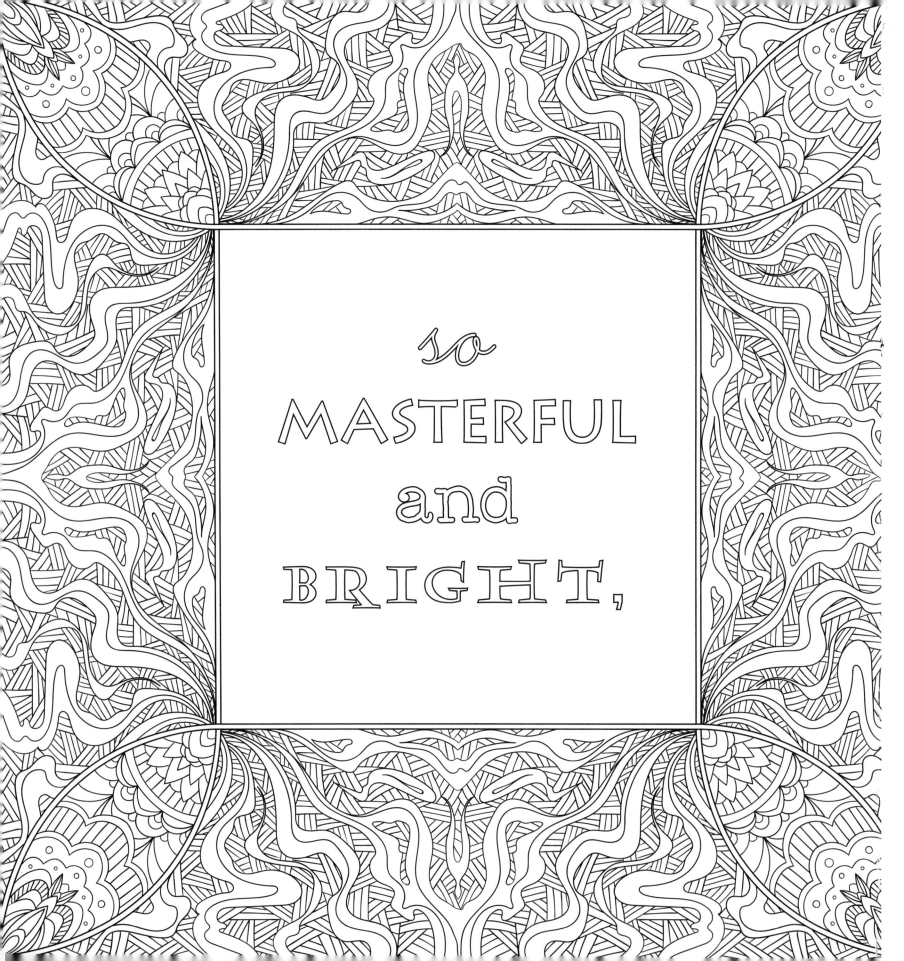

so
MASTERFUL
and
BRIGHT,

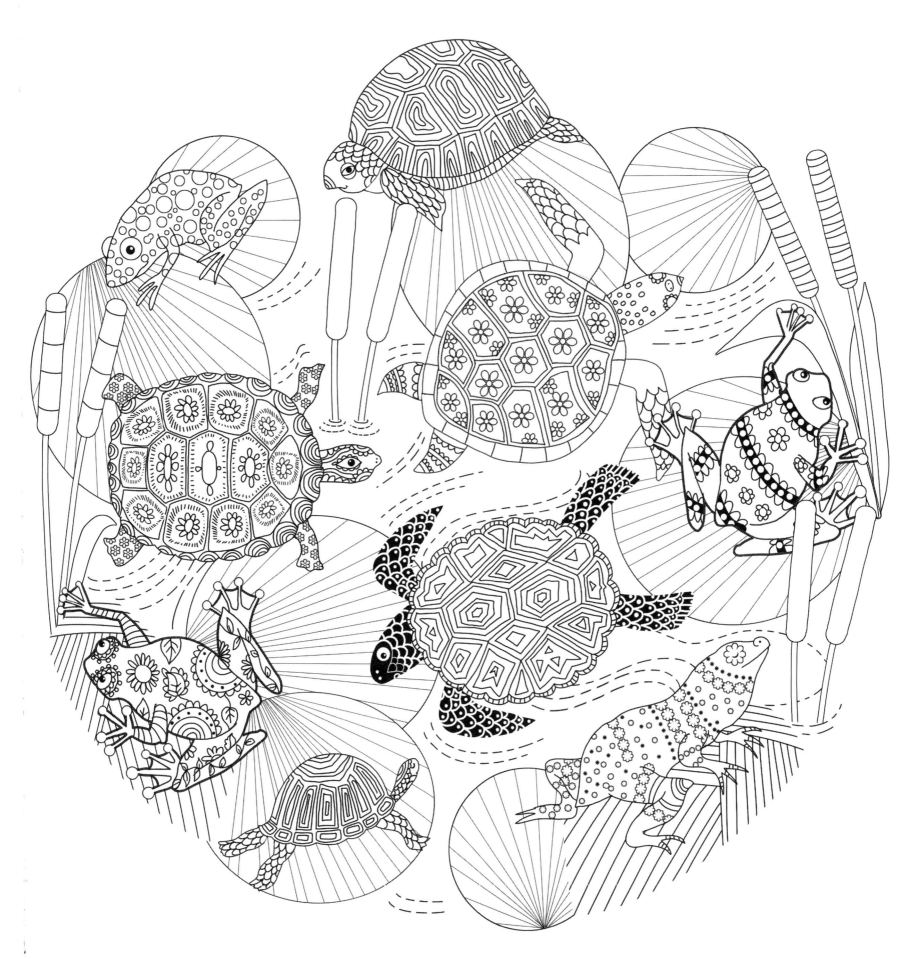

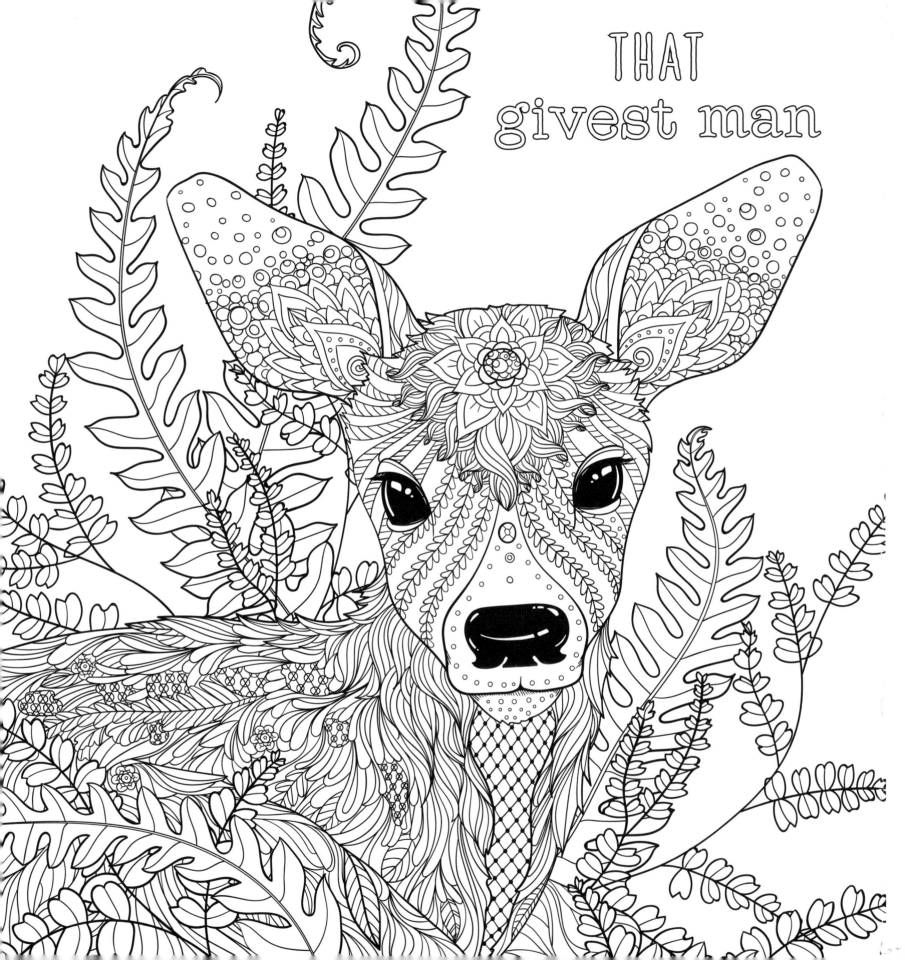

THAT
givest man

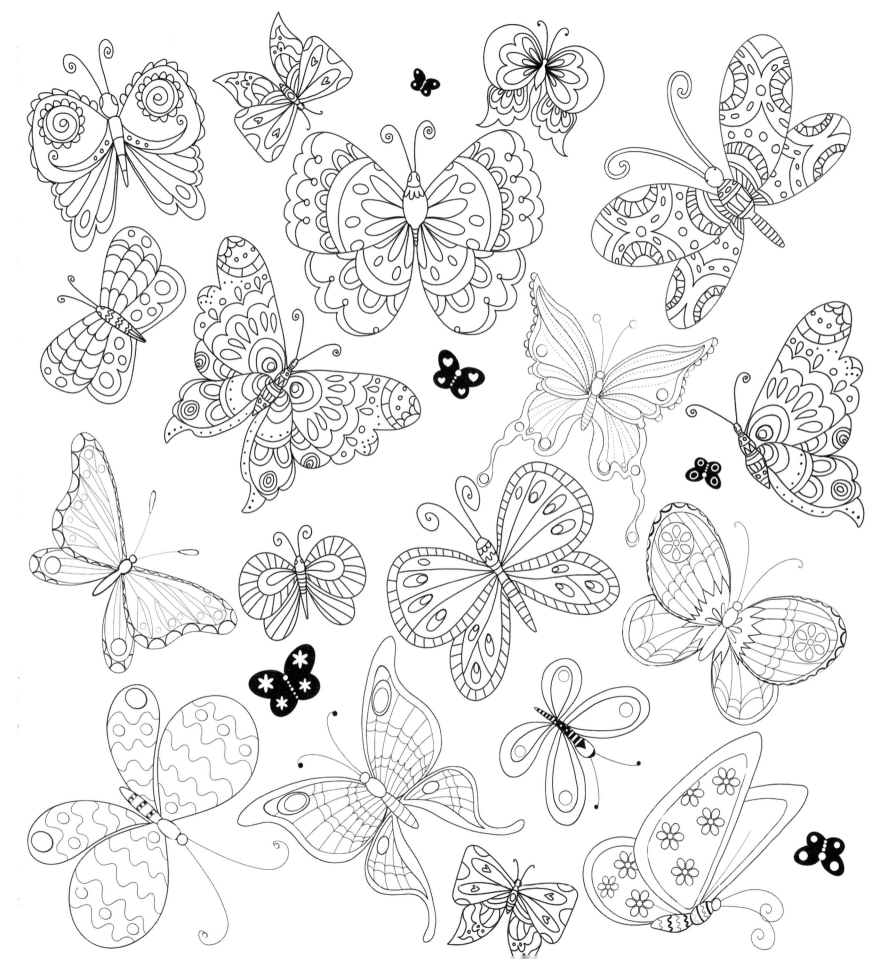

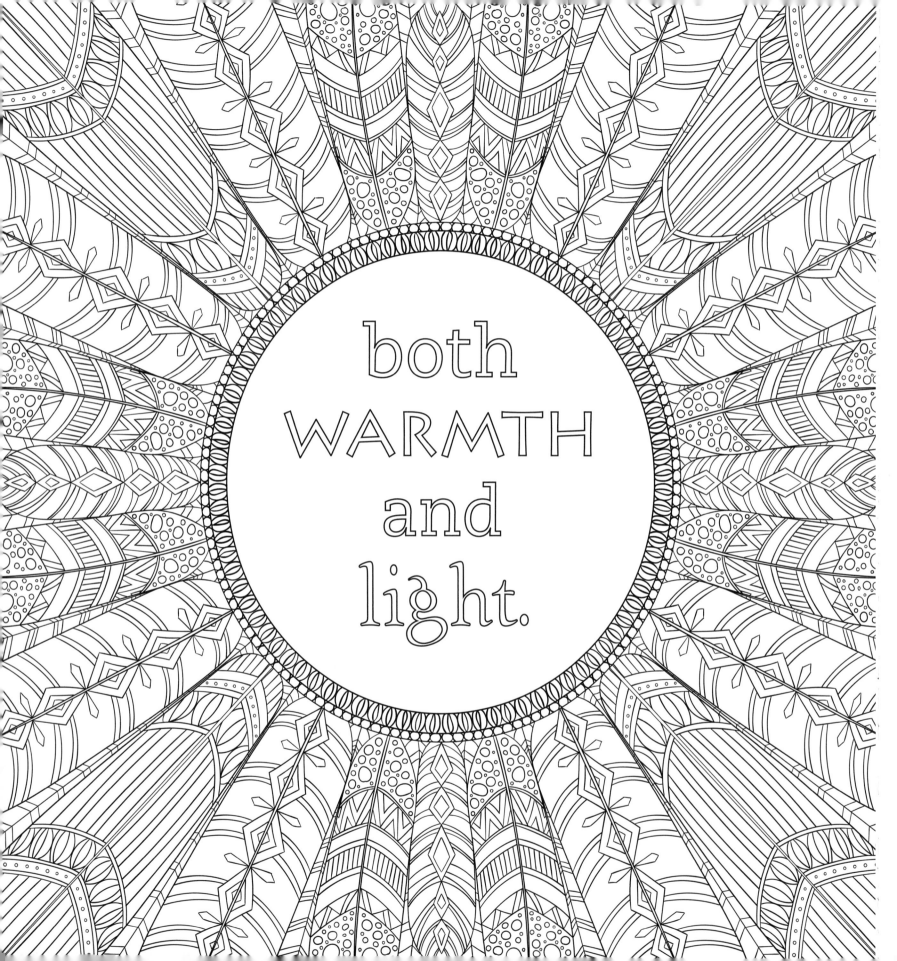

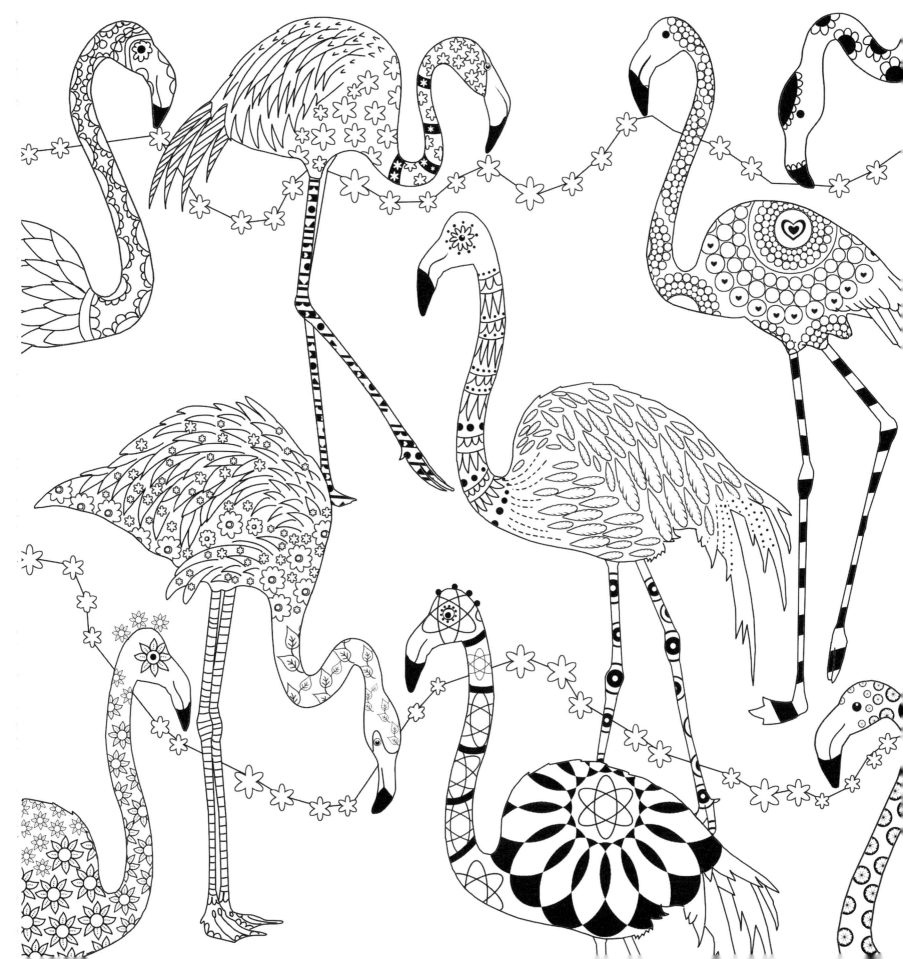

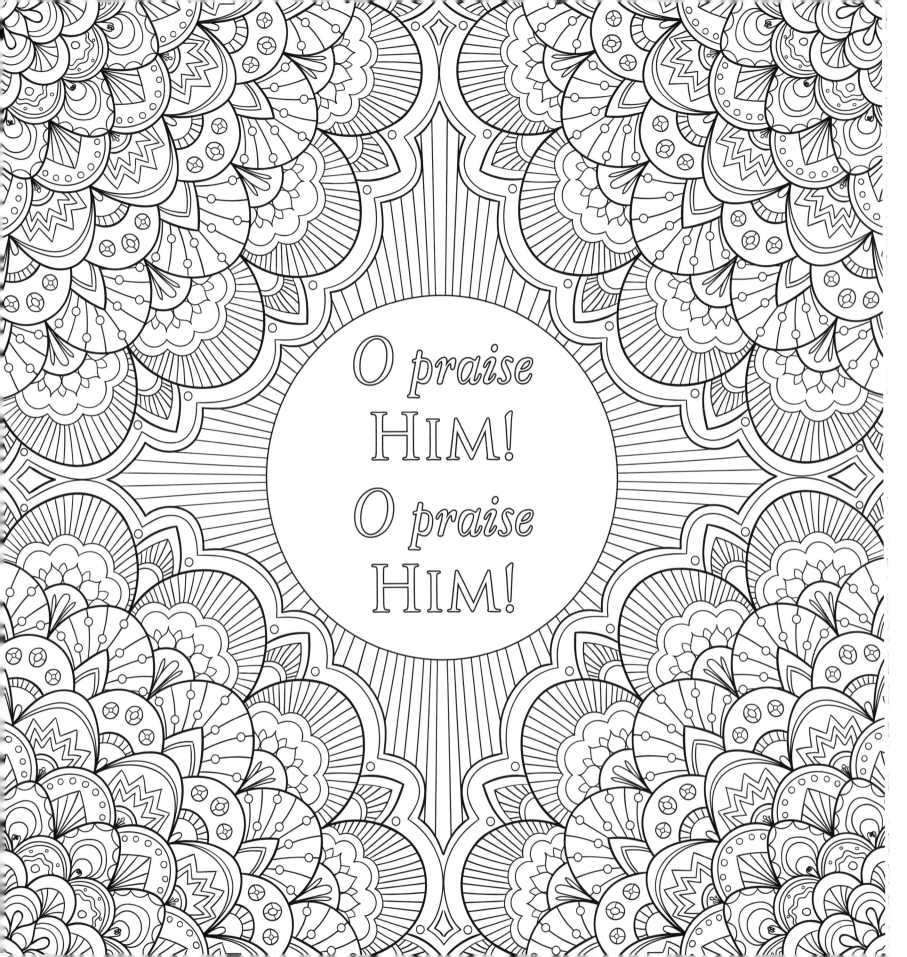

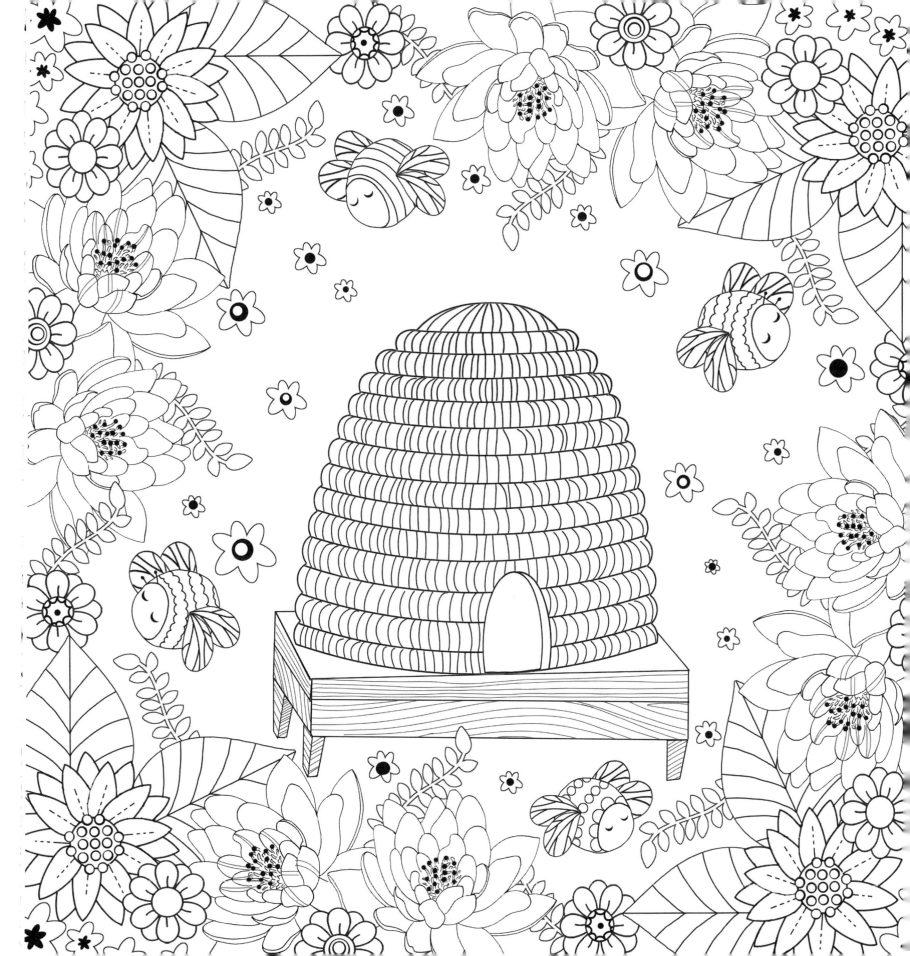

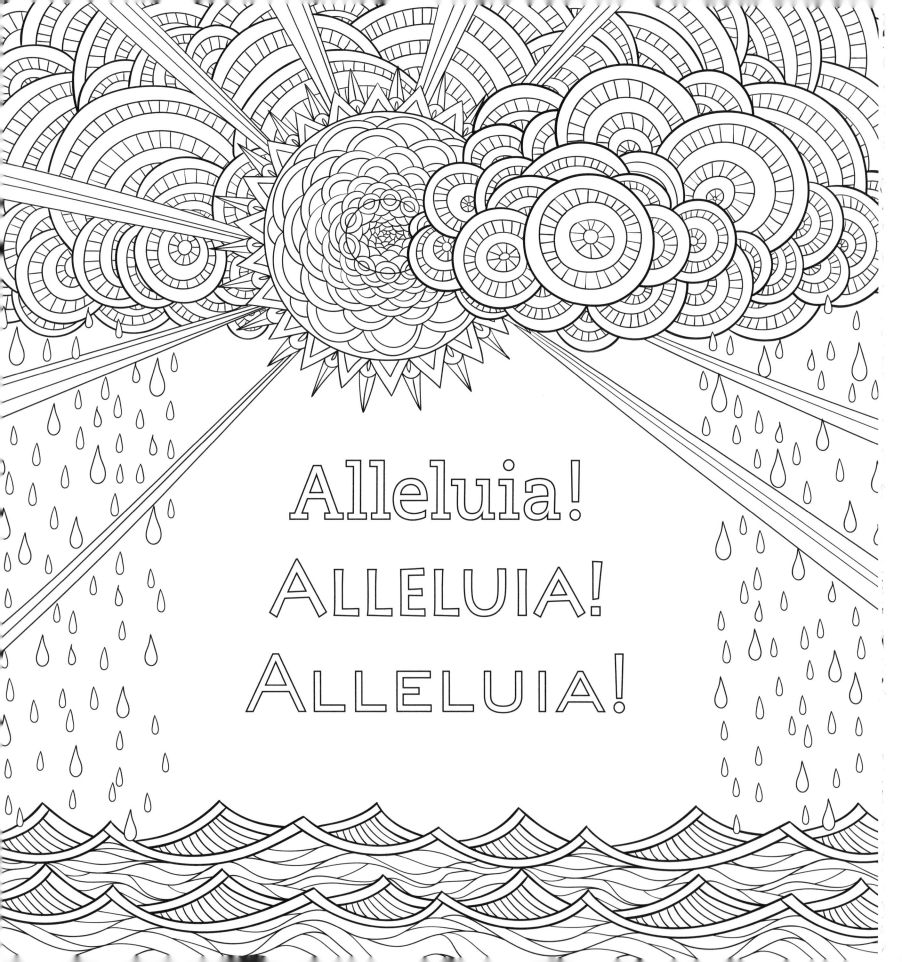

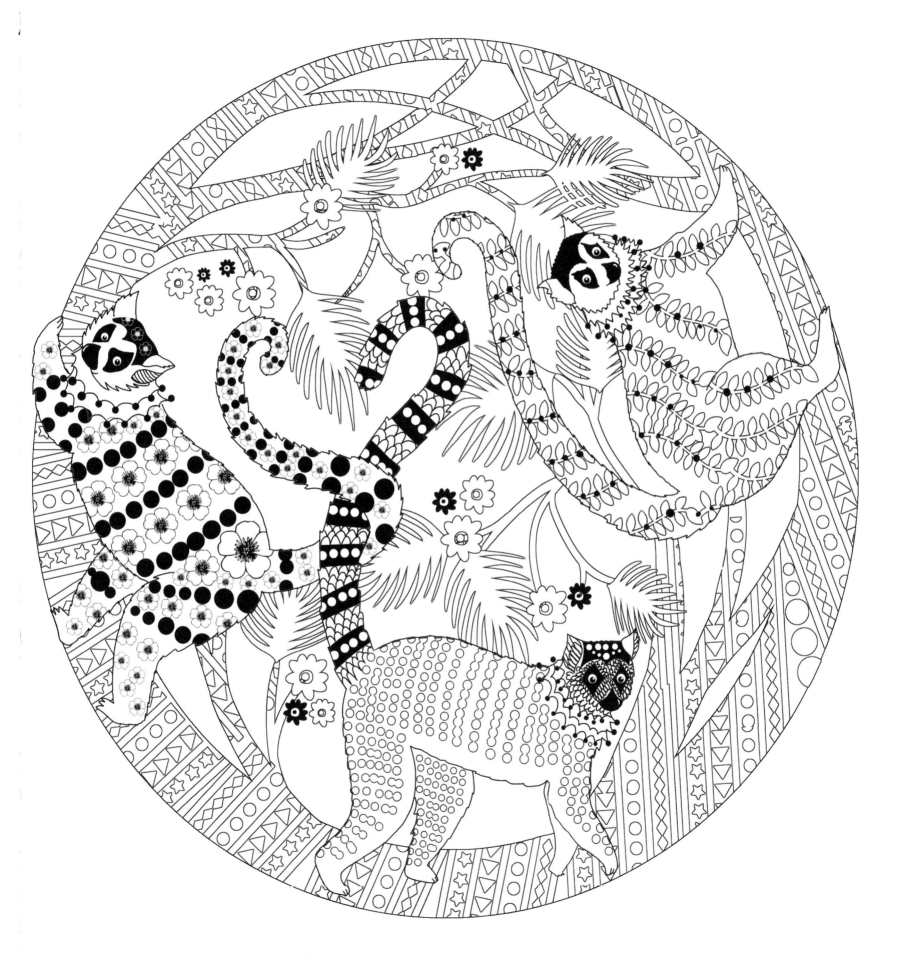

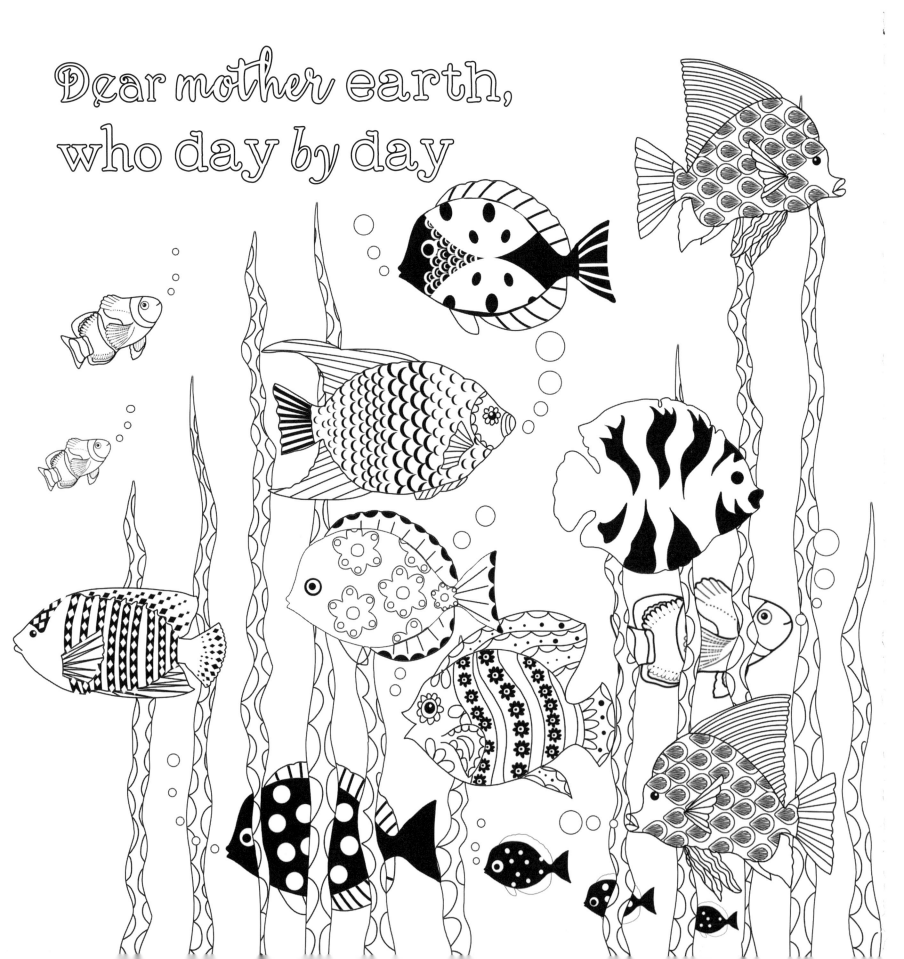

Dear mother earth,
who day by day

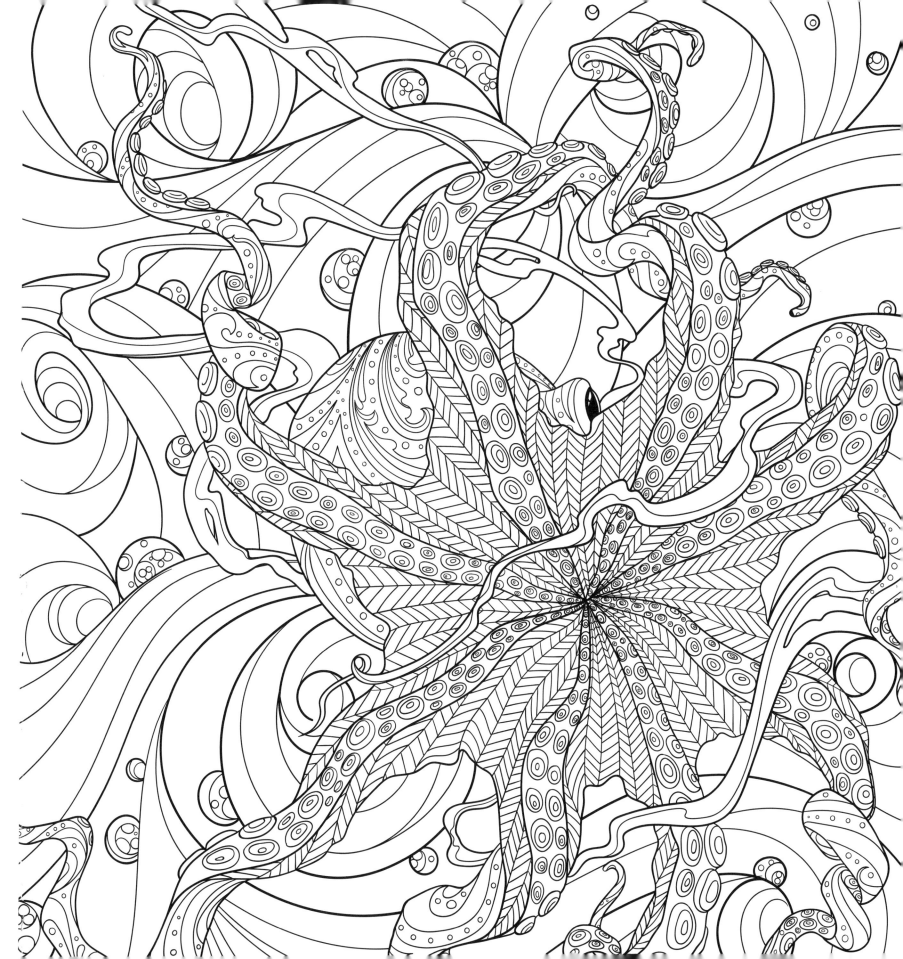

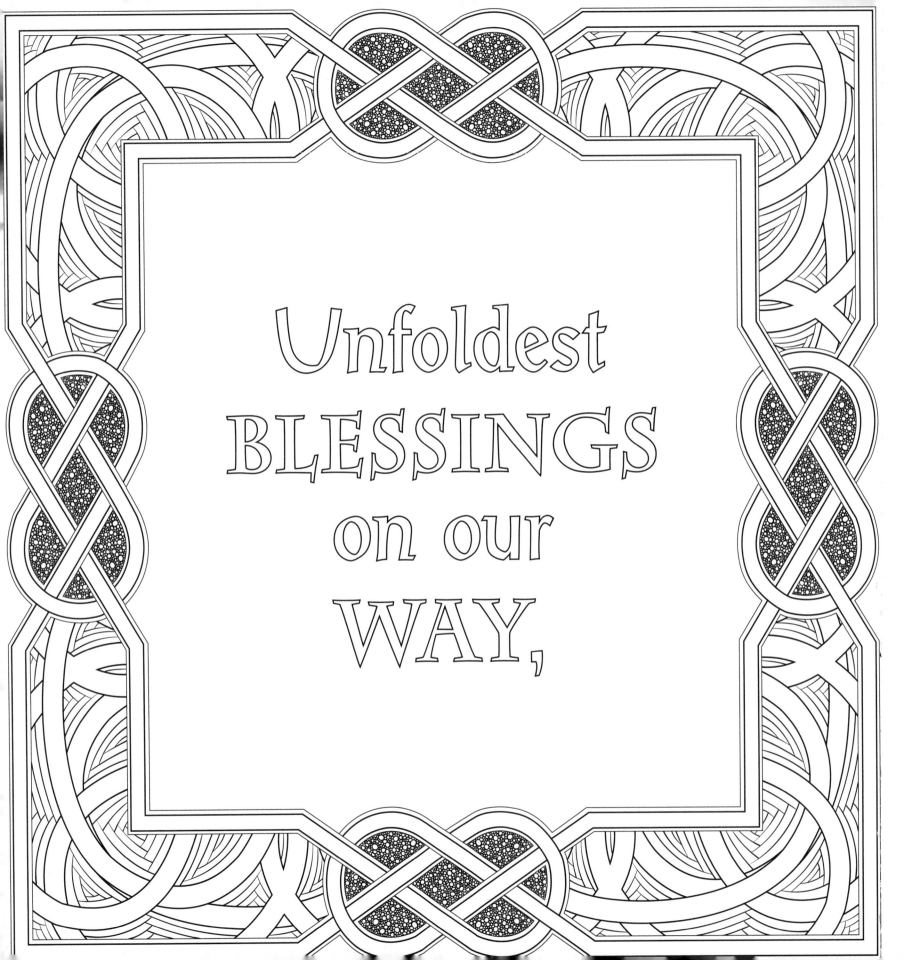

Unfoldest
BLESSINGS
on our
WAY,

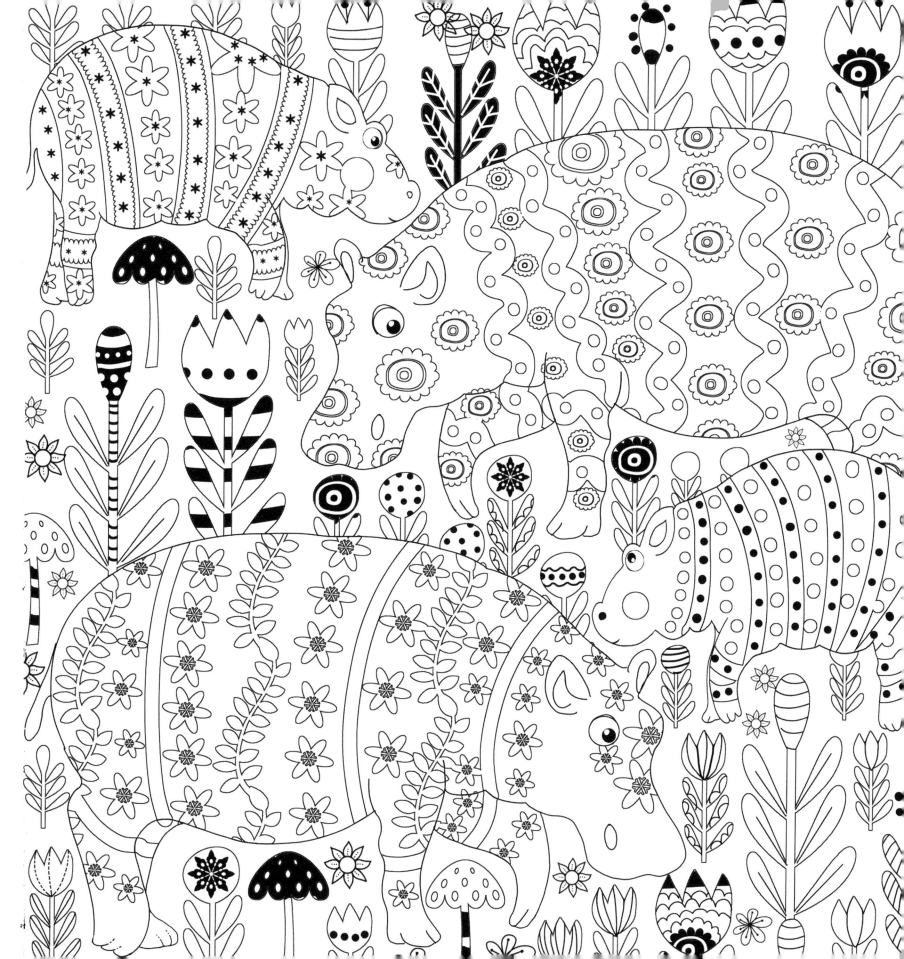

O praise Him! Alleluia!

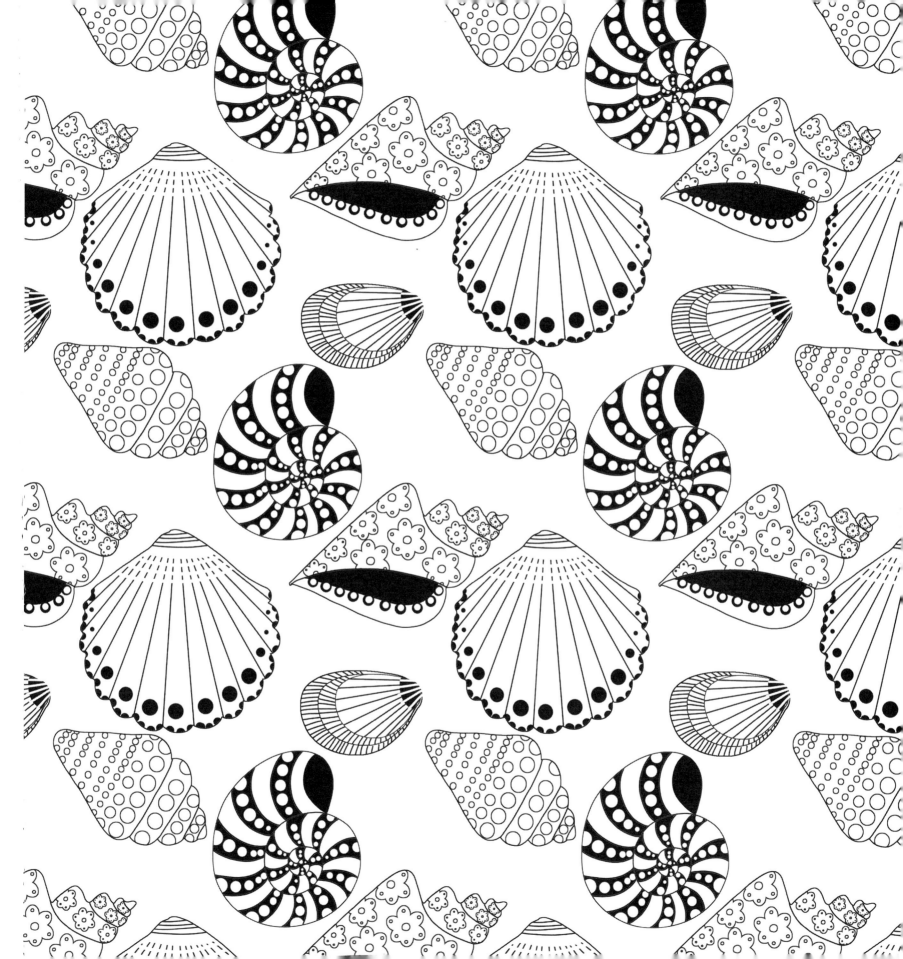

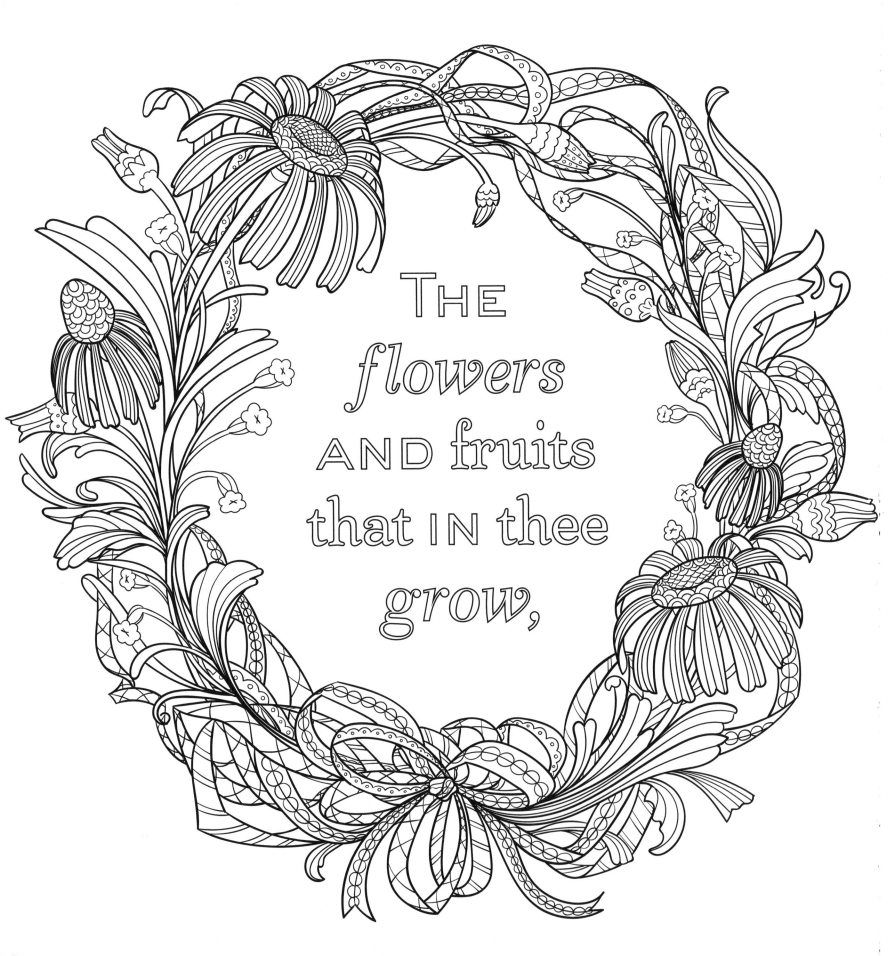

The *flowers* AND fruits that IN thee *grow,*

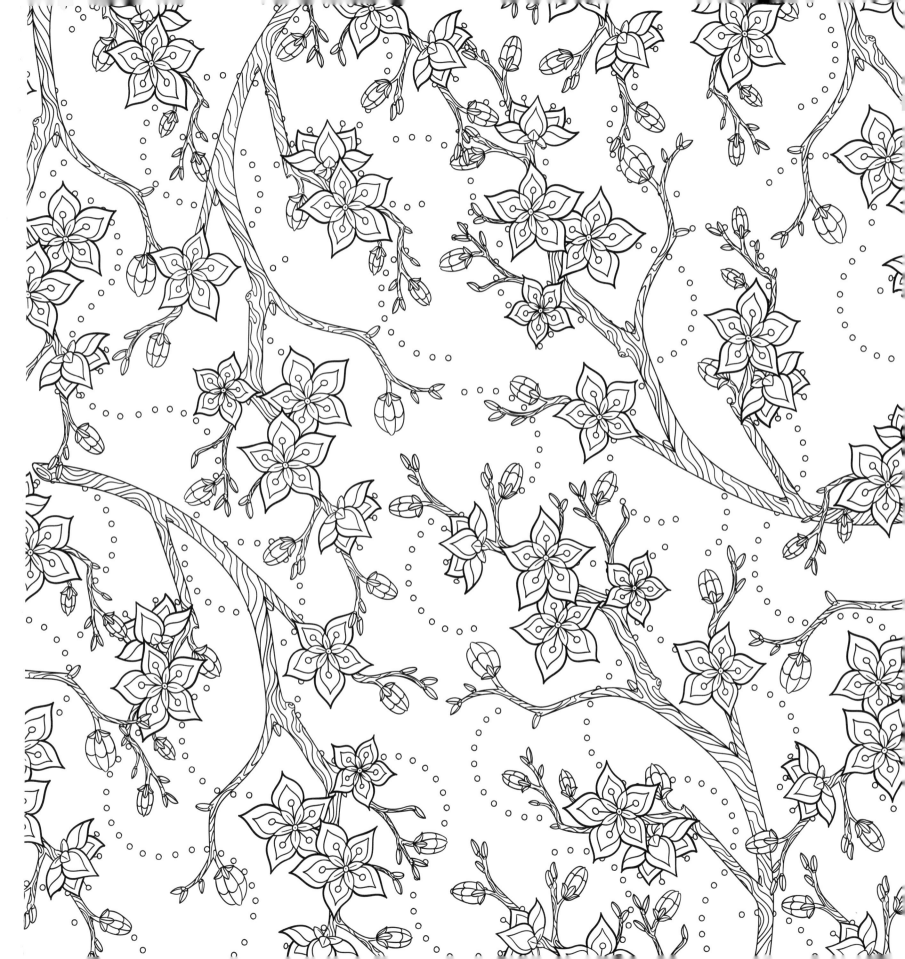

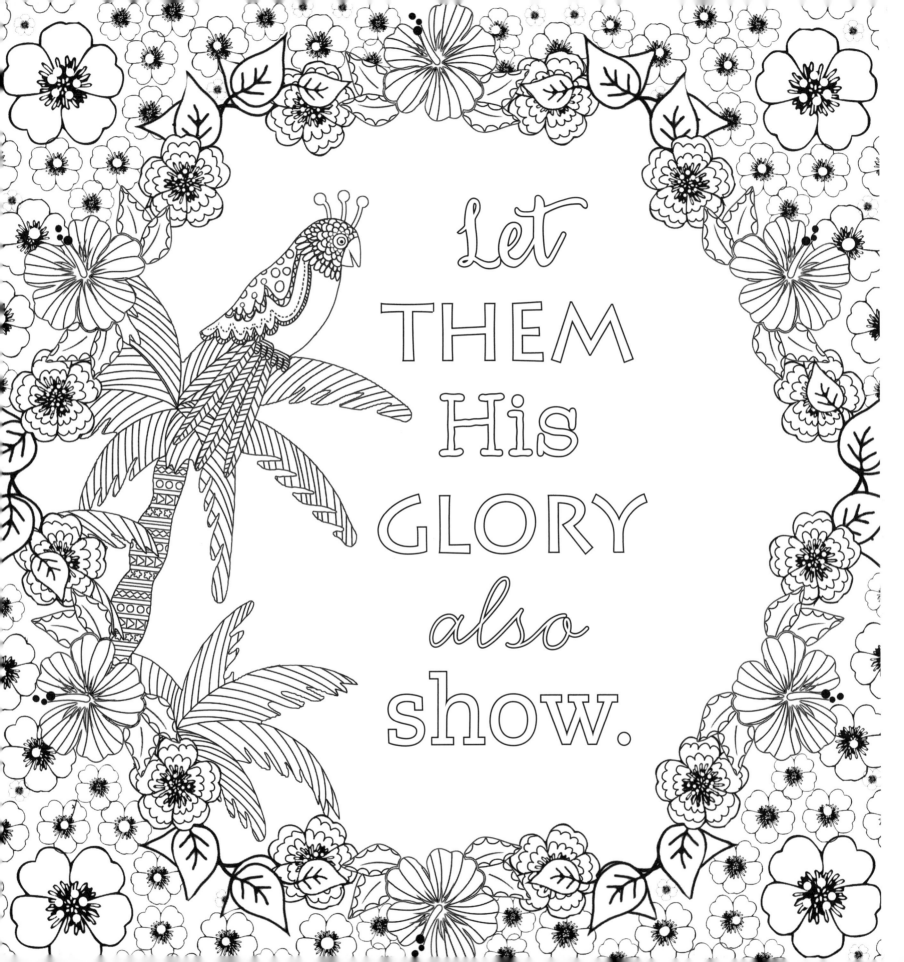

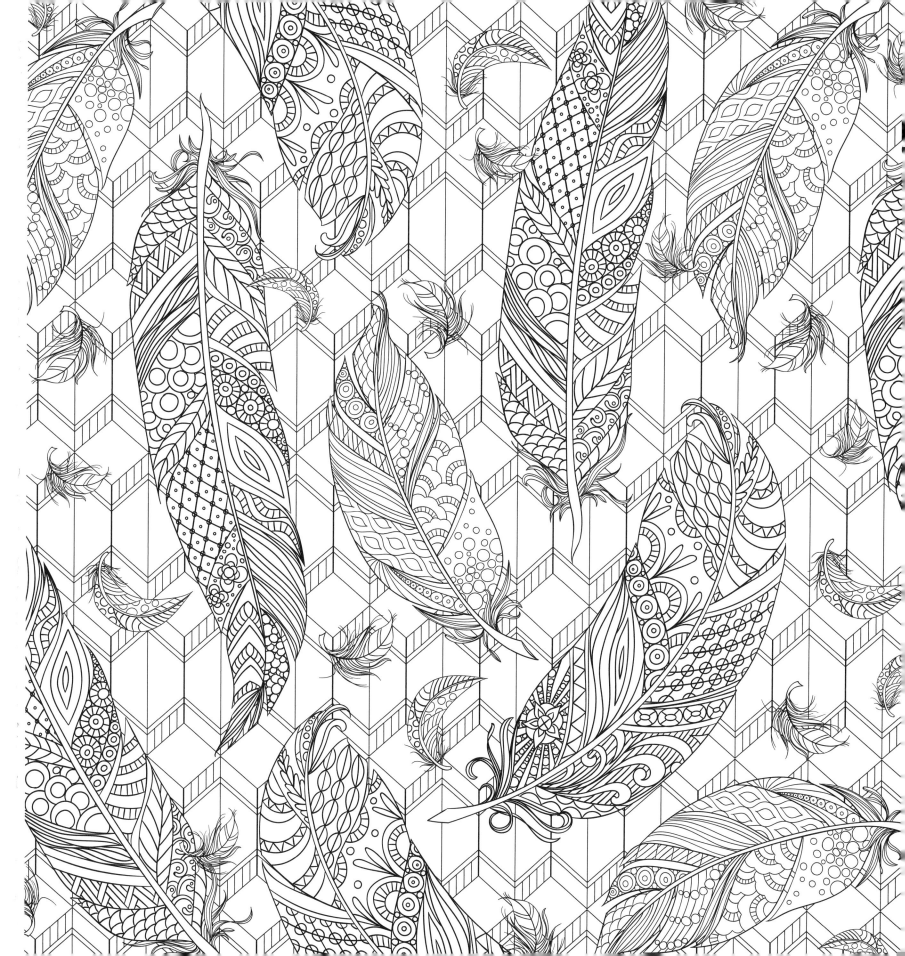

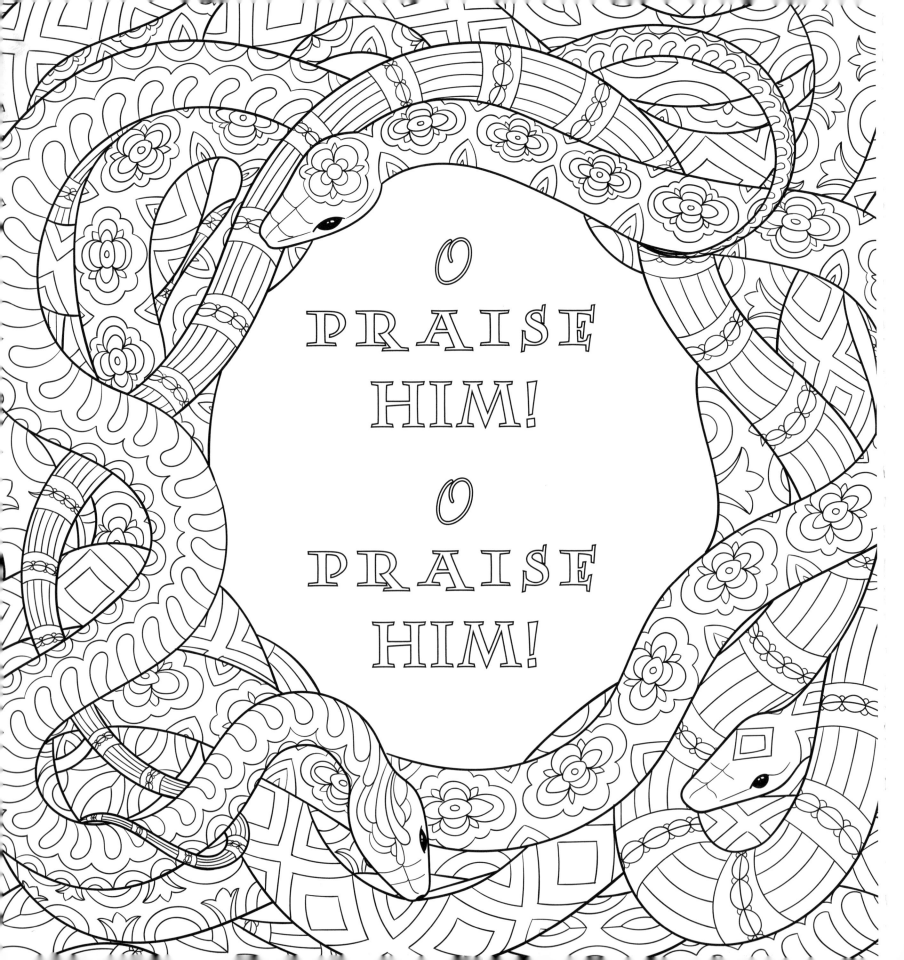

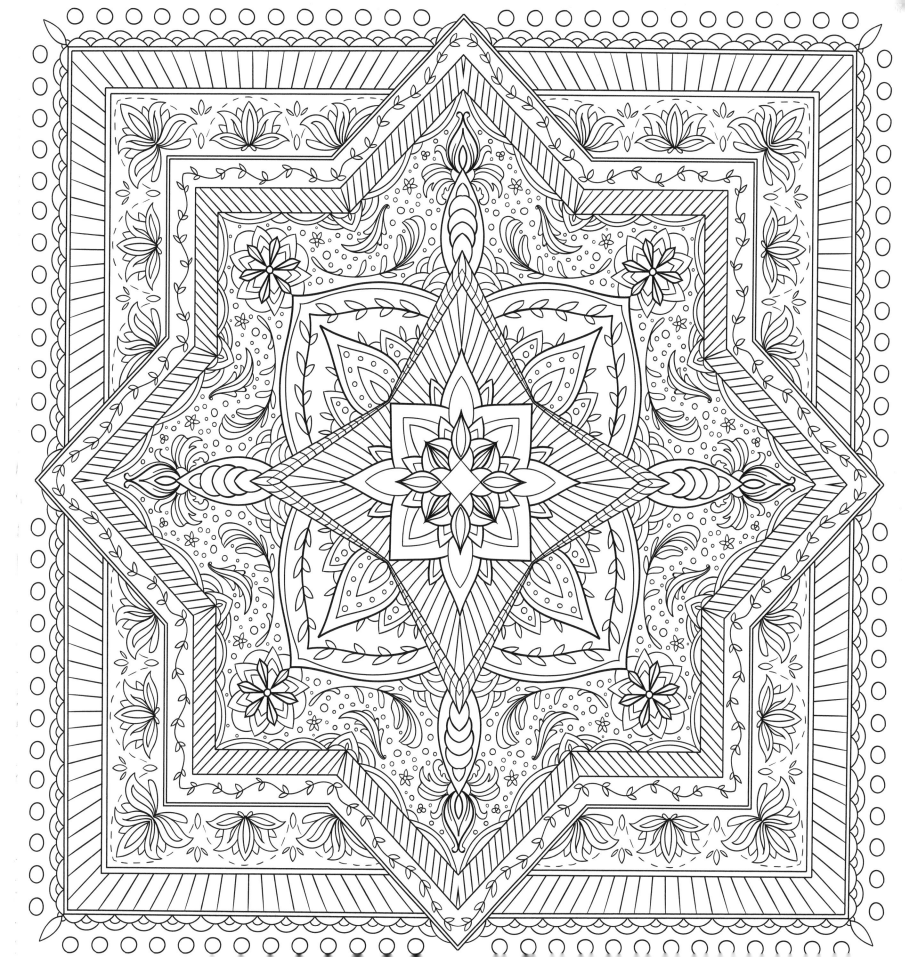

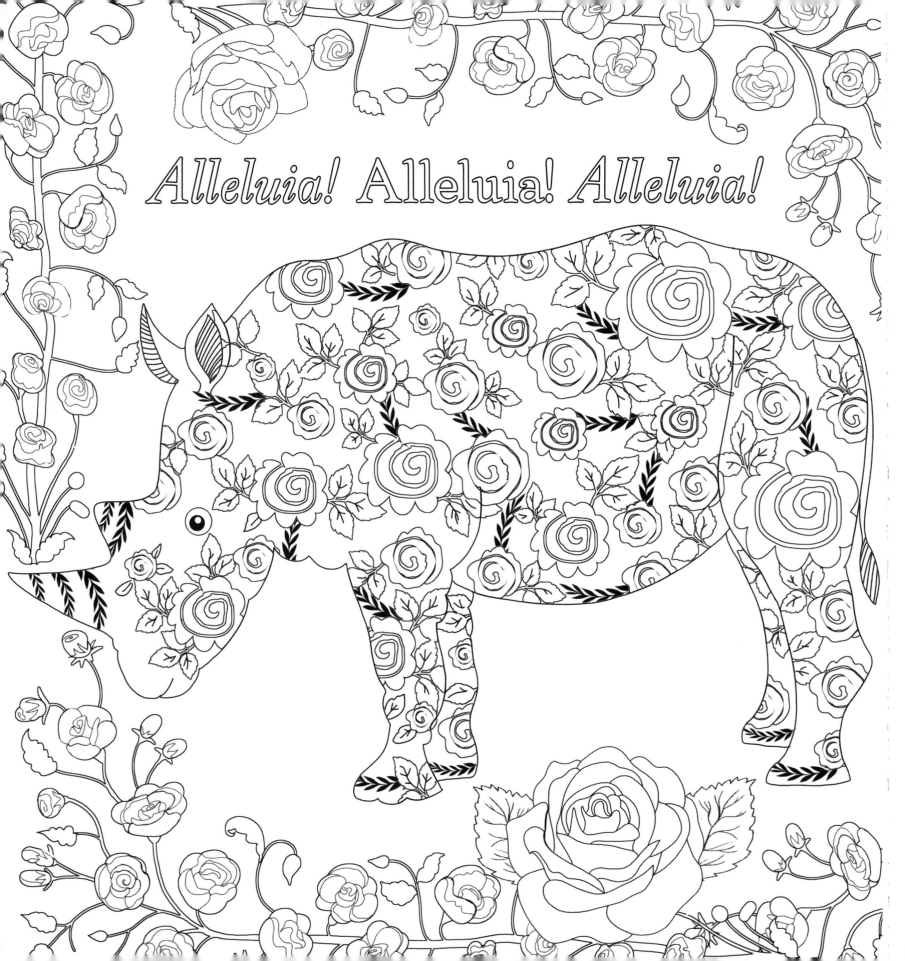

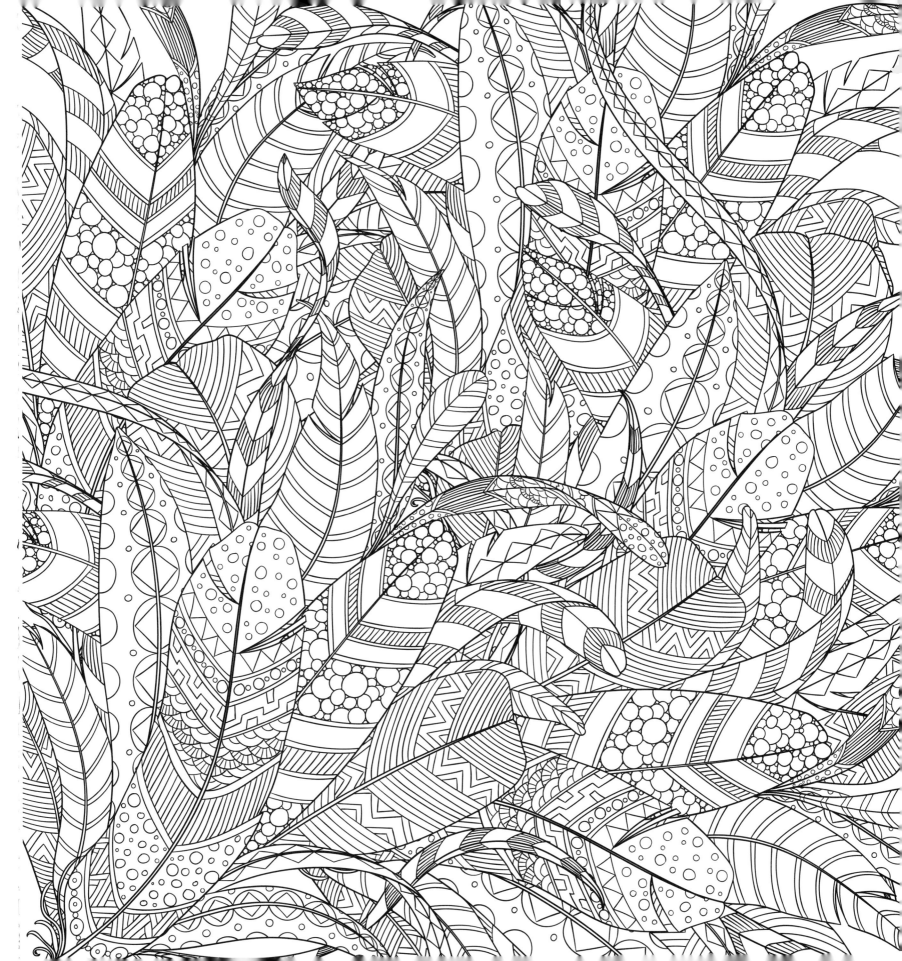

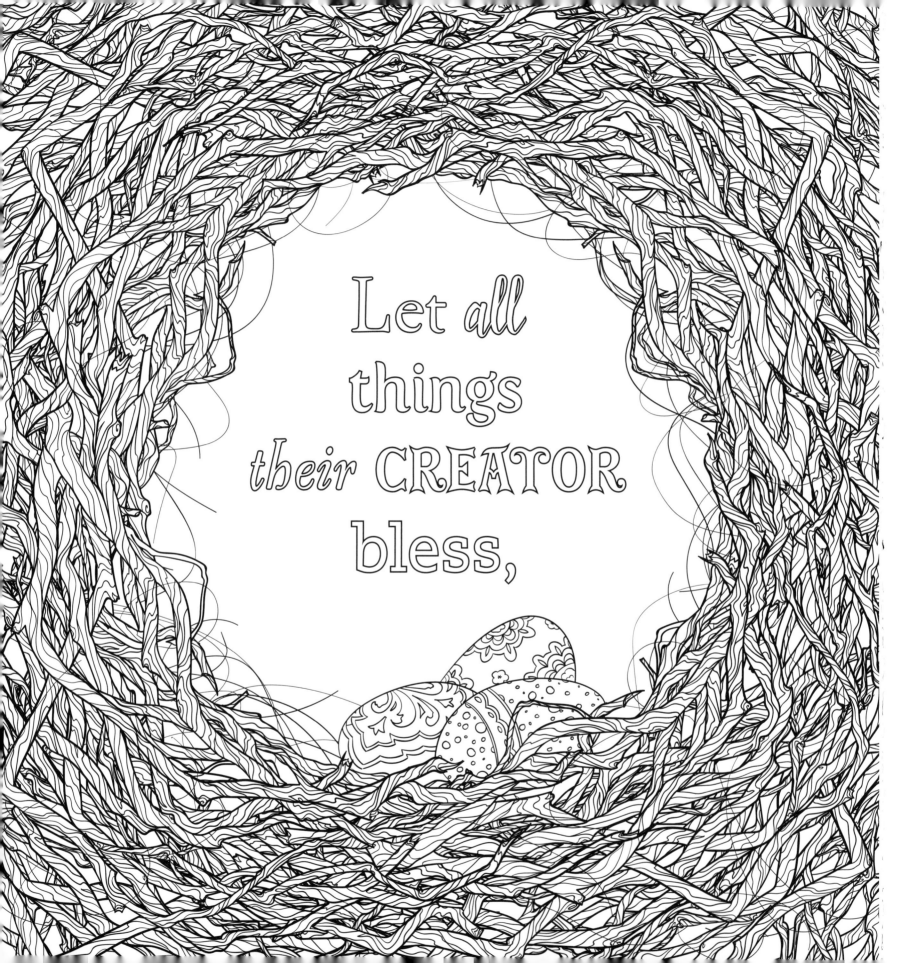

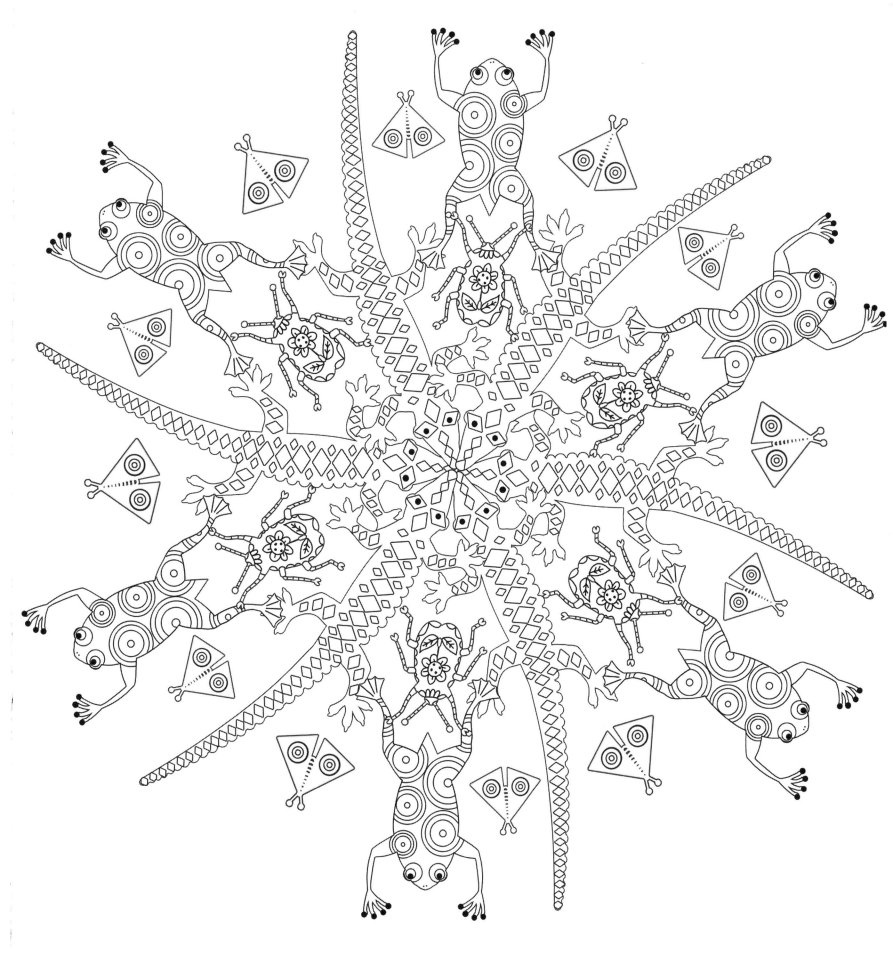

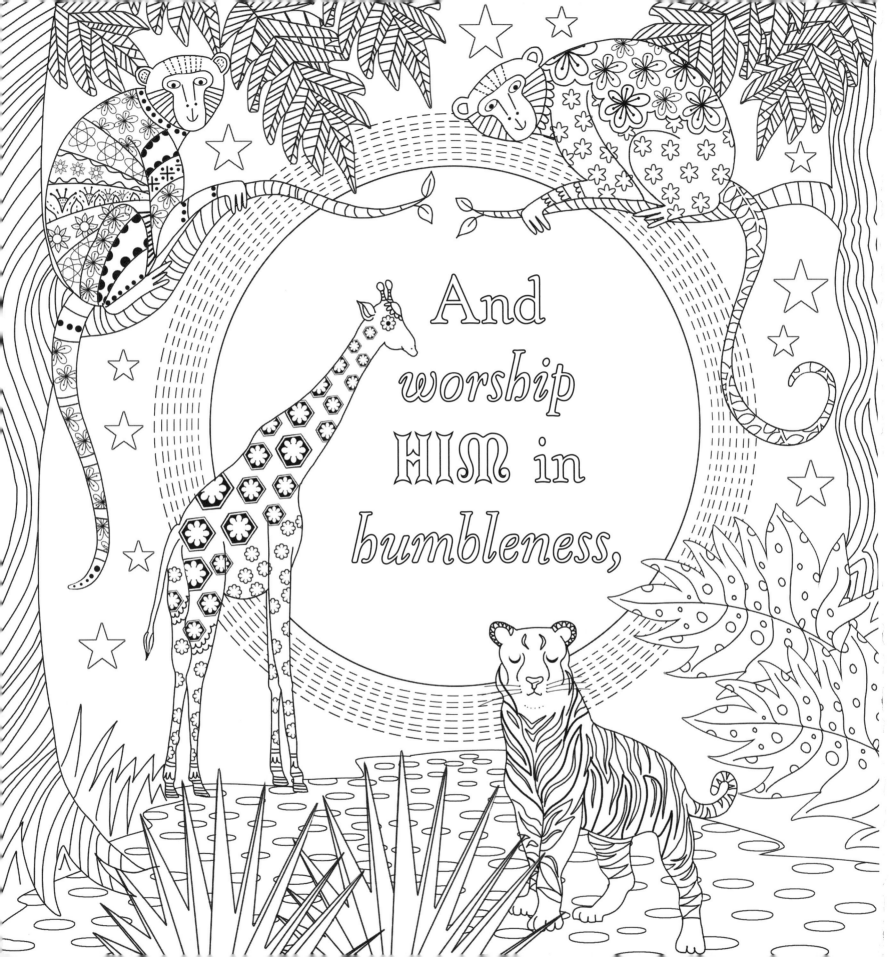

And
worship
HIM in
humbleness,

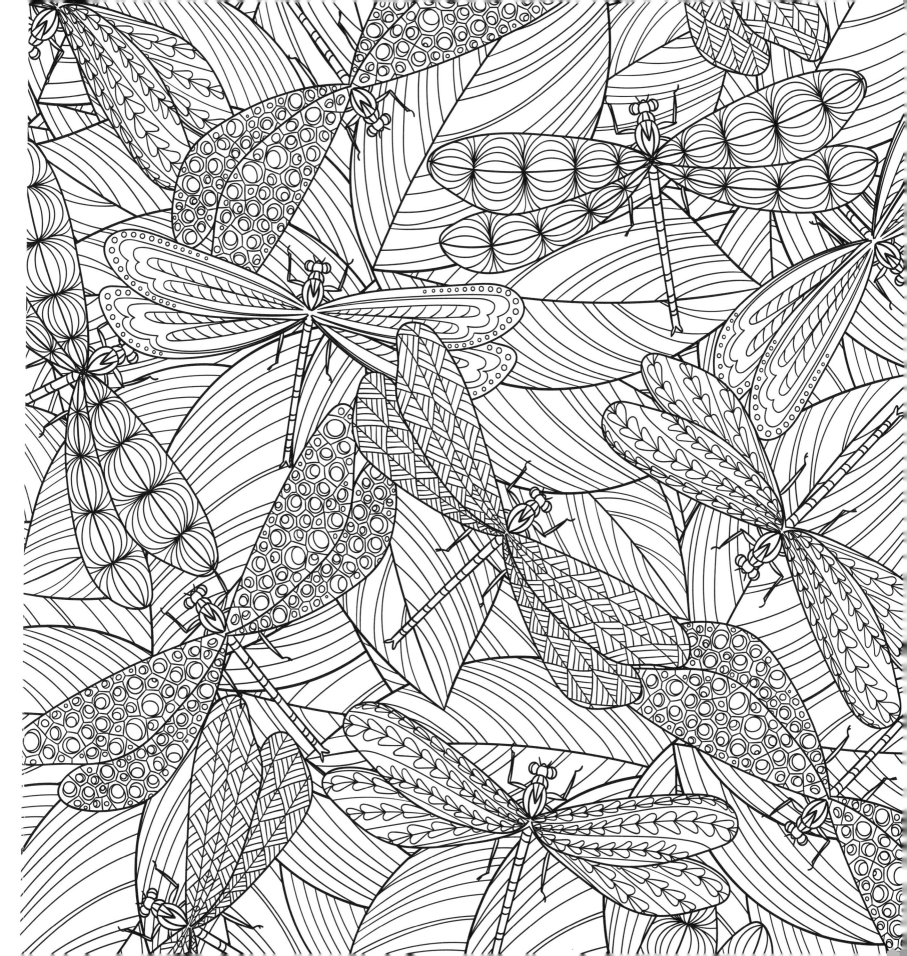

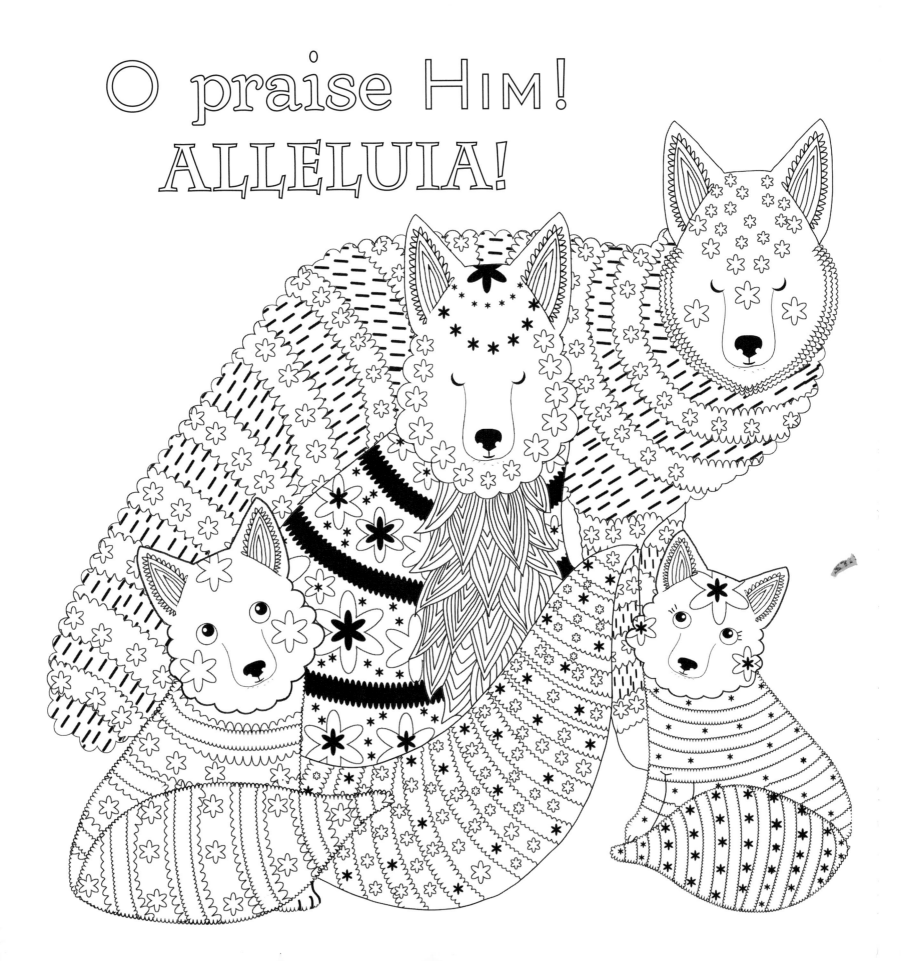

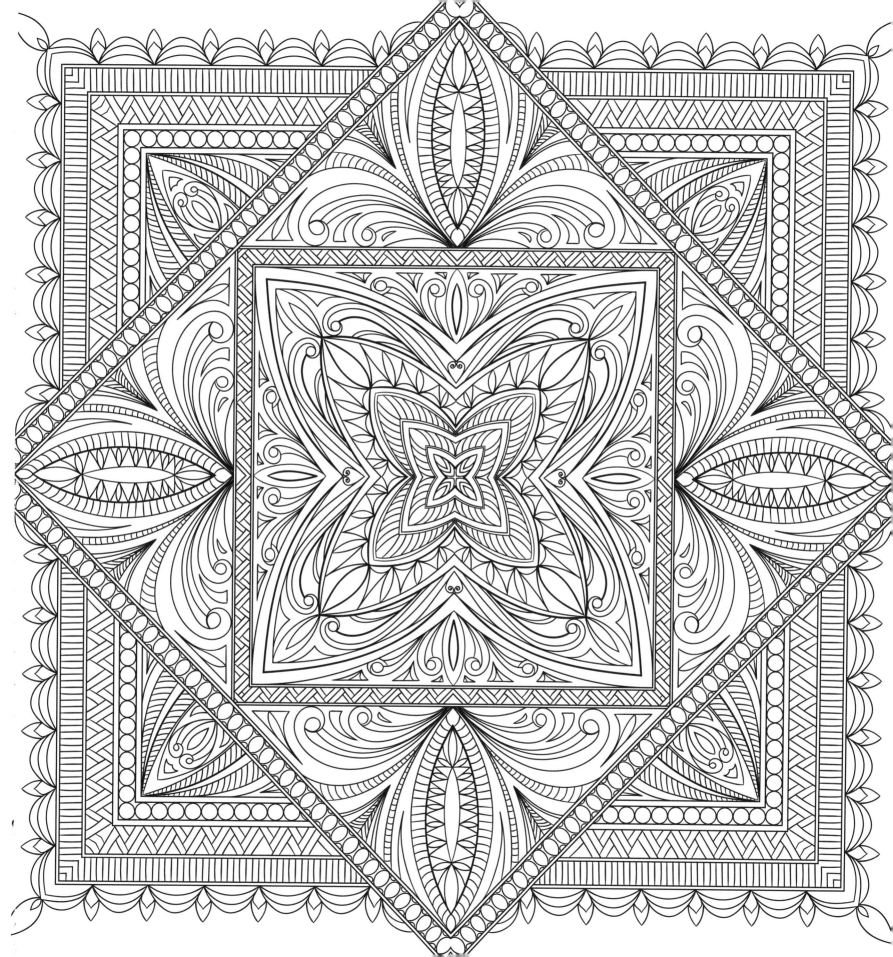

PRAISE, praise *the* FATHER, praise *the* SON,

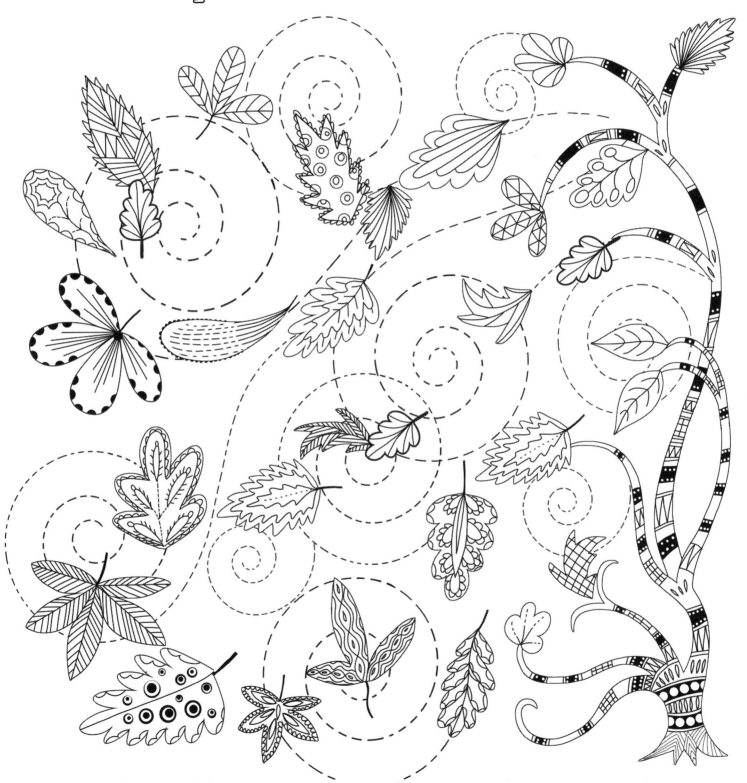

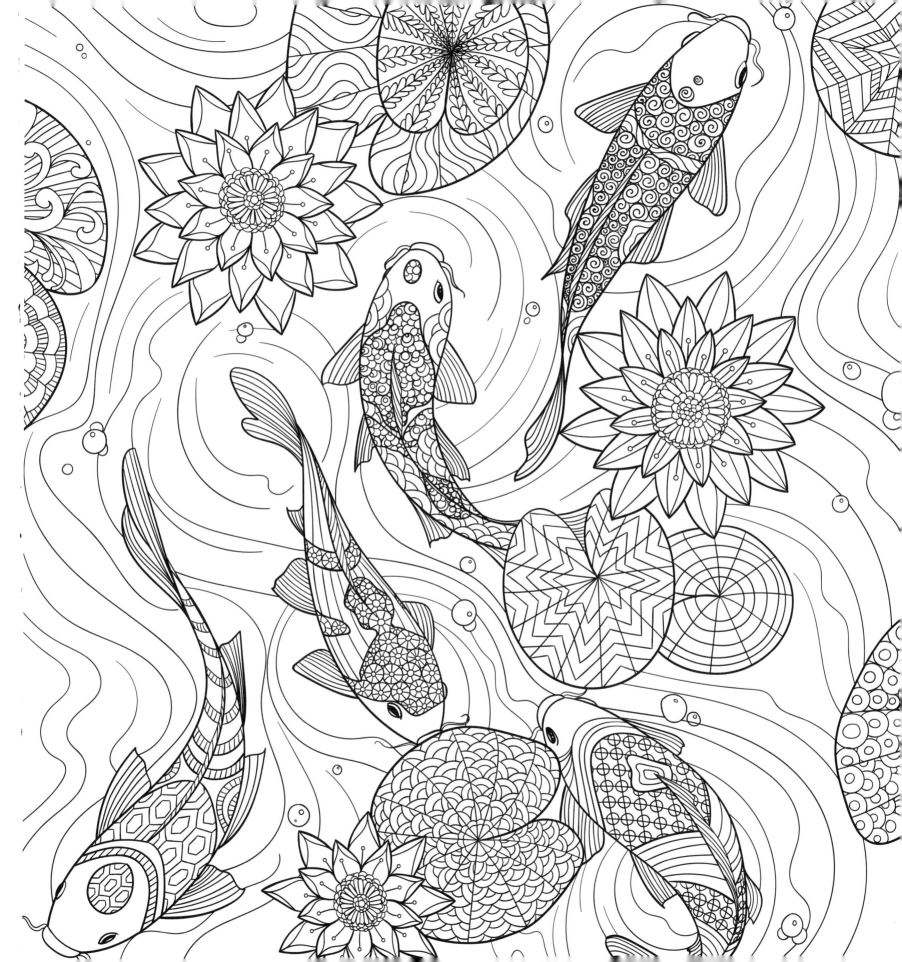

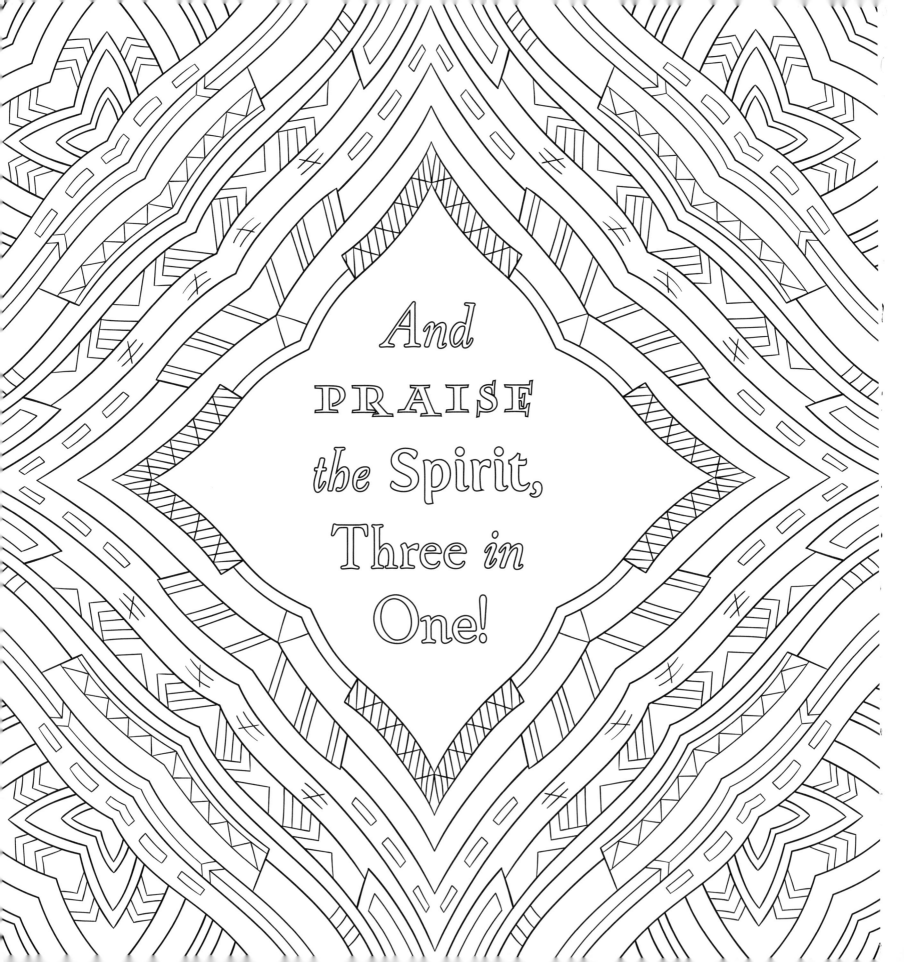

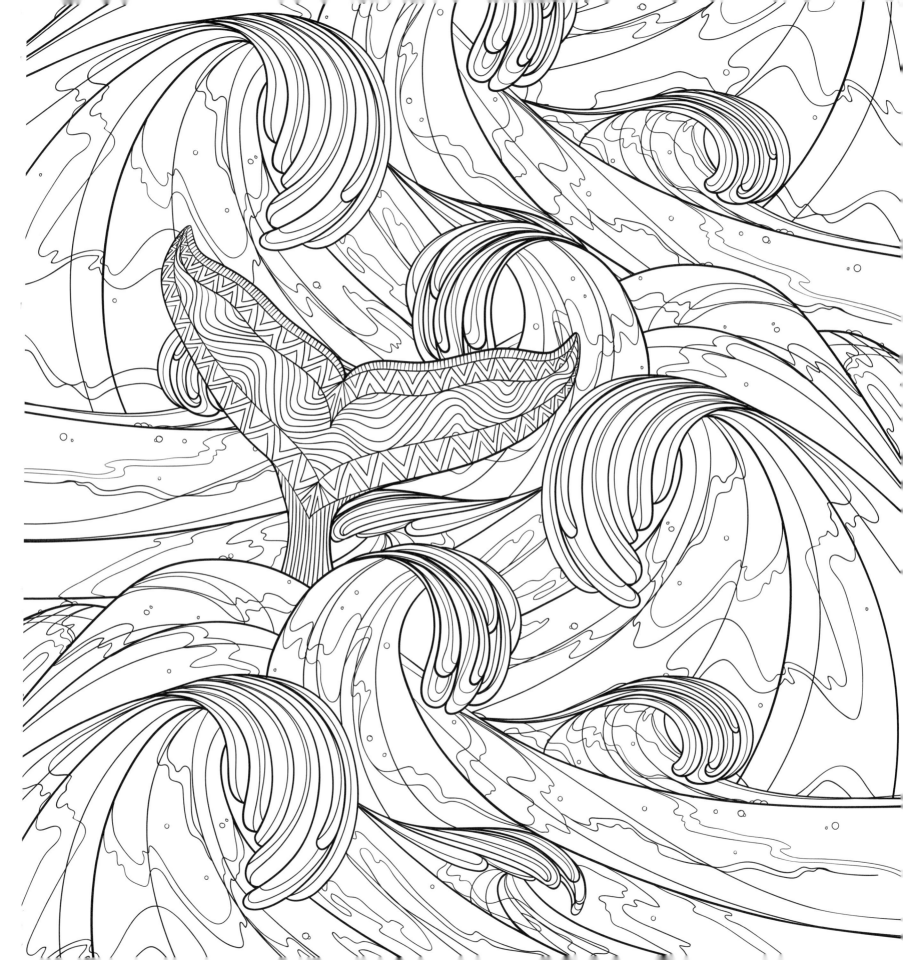

O PRAISE HIM! O PRAISE HIM!

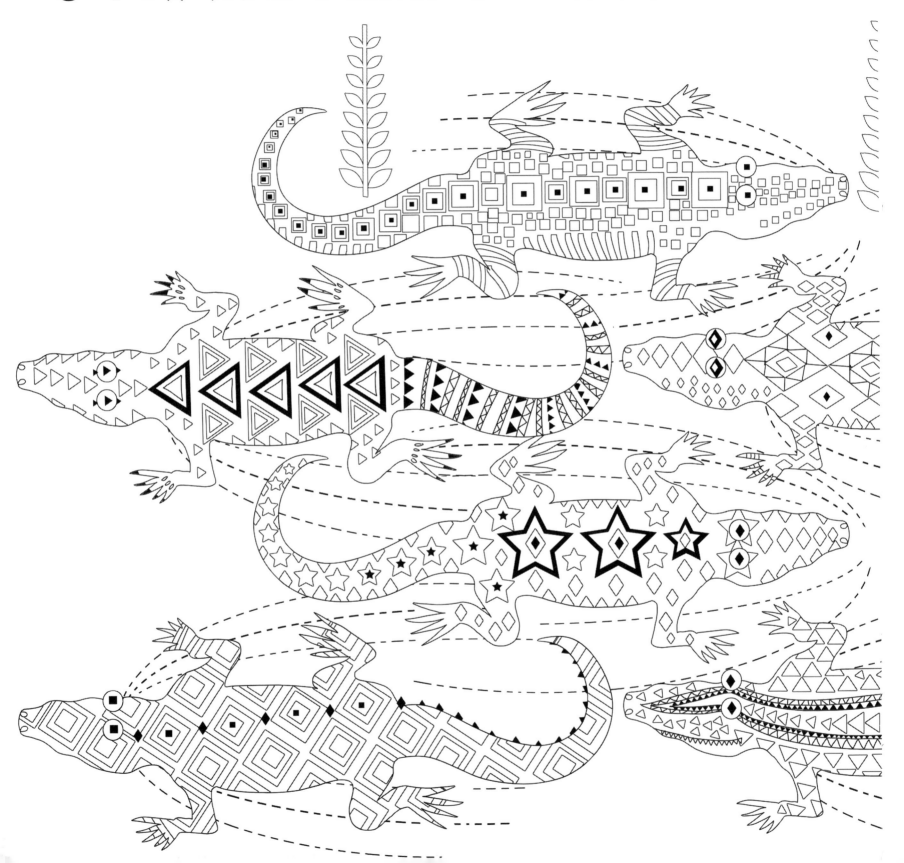

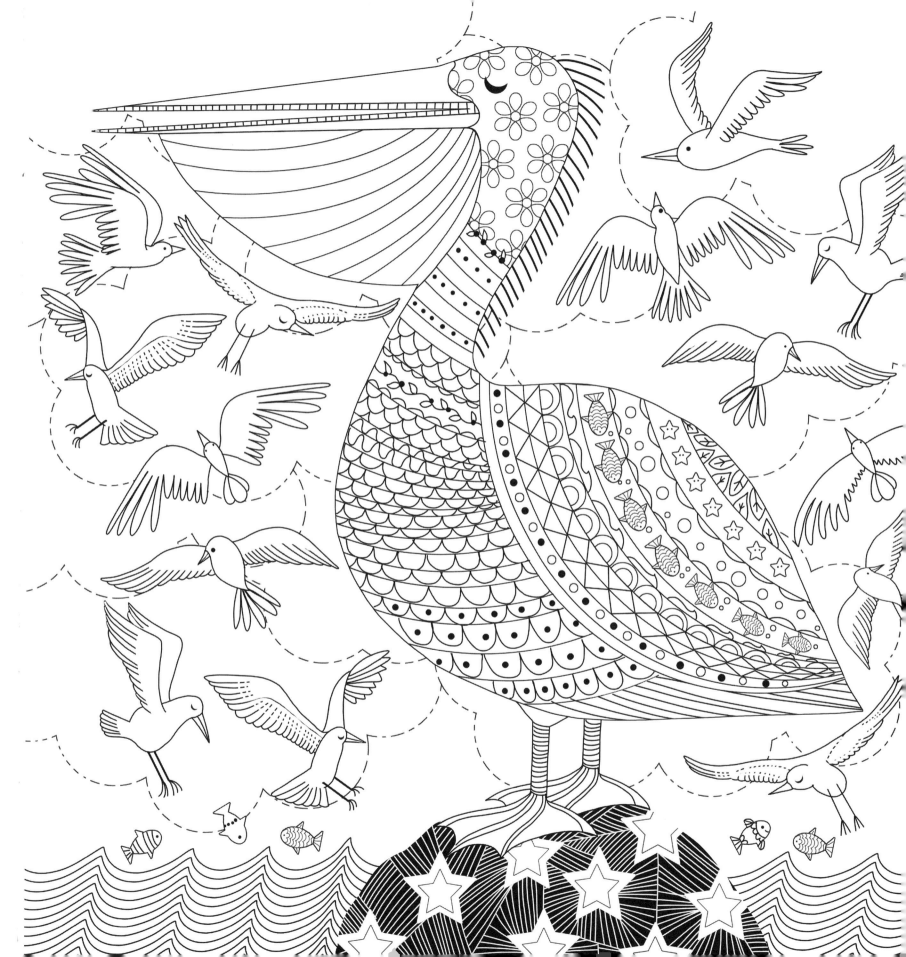

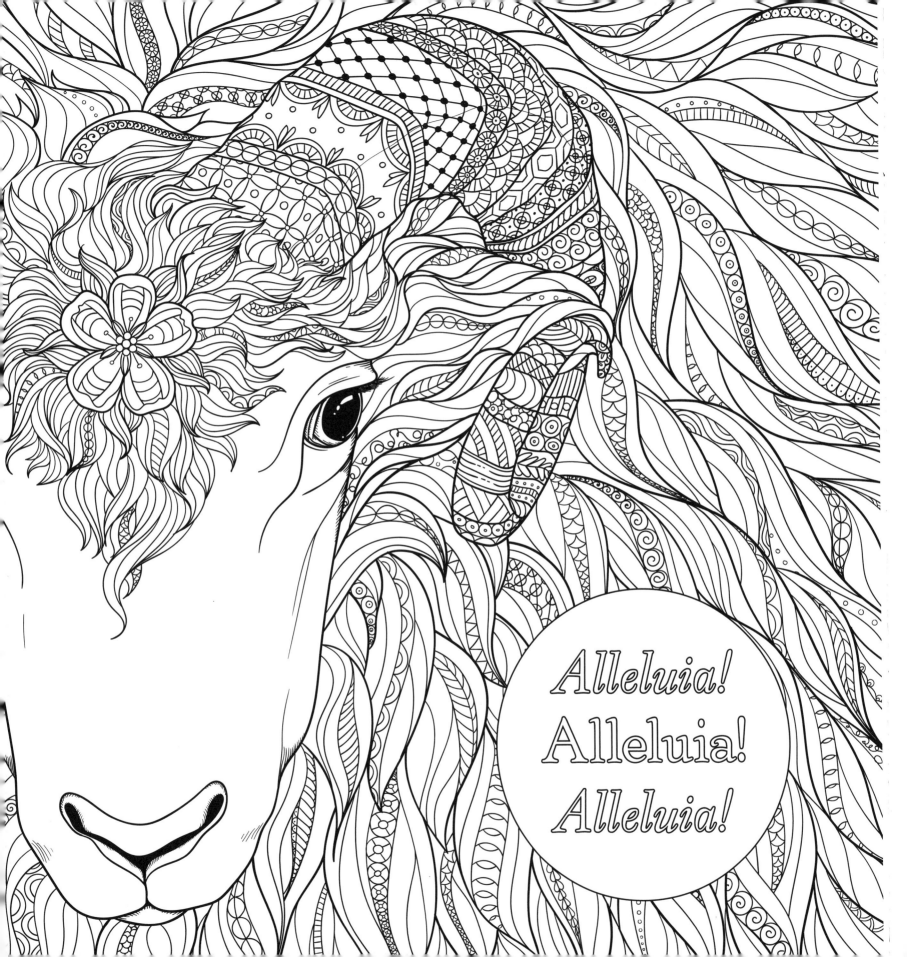

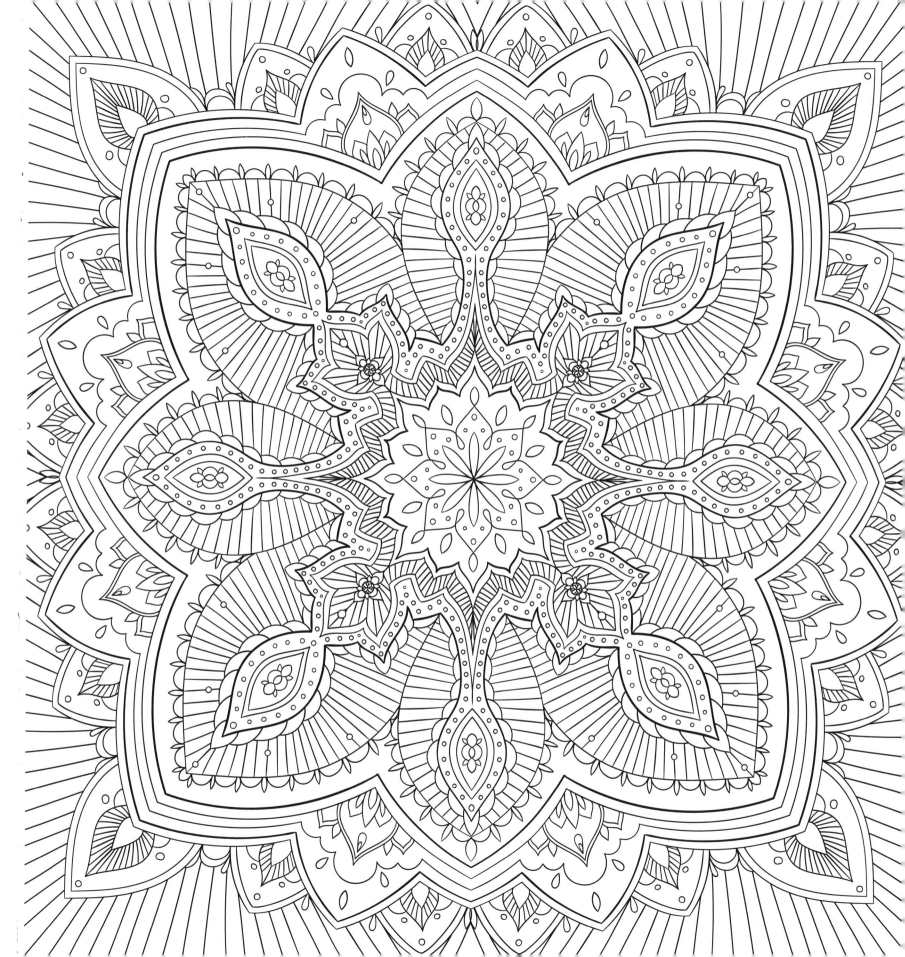